A Wild Journey
Through Swiss Customs
and Traditions

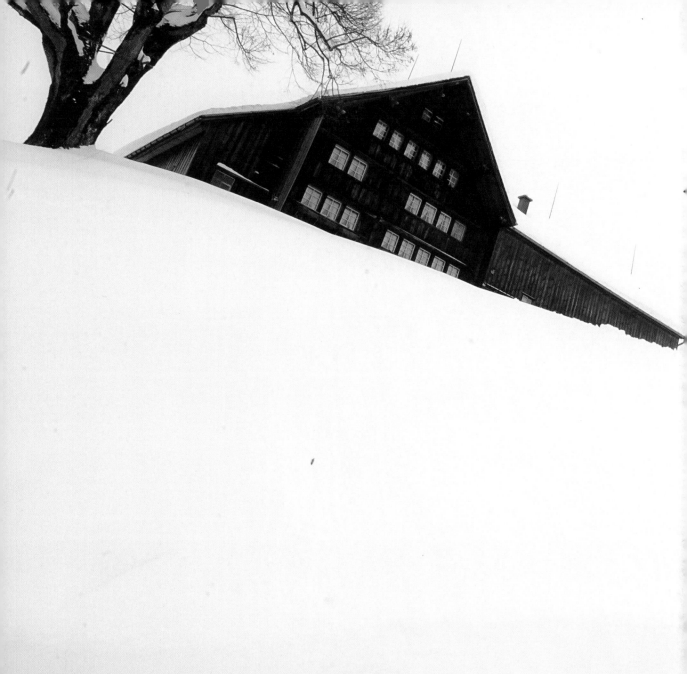

dancing pines

A Wild Journey Through Swiss Customs and Traditions

DOMINIQUE ROSENMUND,
SIBYLLE GERBER, KARIN BRITSCH &
STEPHANIE HESS

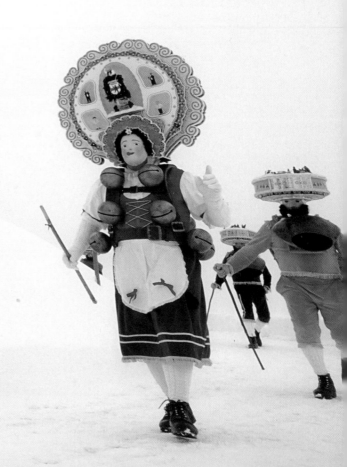

BENTELI

CONTENTS

Urnäsch, January 13. It's not dawn yet. An old farm-house in the snow. The lights are on in two windows. A wife helps her husband to pull on thick stockings, a velvet skirt and a white blouse with puffed sleeves. Breakfast is ready in the kitchen. One after another men arrive and sit around the large table. The women bring fresh coffee, bread, eggs and bacon. There is a festive atmosphere in the room. The only sound that can be heard is the faint clatter of the cutlery.

Early in the morning on the day of Silvester-chlausen it is already apparent that those gathered there belong together in a special way. What they do seems carefully coordinated as if it were written down in an invisible screenplay.

Customs can unite us in the moment of the shared experience: the individual recedes in the background, becoming part of a community. The screenplay for these collective experiences is passed on from one generation to the next, adapted and changed along the way. "Many people believe that Chlausen was always like today, but that's not true. If a custom doesn't change, it dies out", says Walter Frick, one of the men at the breakfast table. Traditions are the living, evolving continuity of experience our grandfathers and great grandmothers already had. Traditions build a bridge to the past and point at the same time to the future because by living out the customs we pass on the screenplay.

Tradition creates a particular place for us in the present. In these fast-moving times, in a mobile, flexible world we can no longer take such a place for granted. In answer to the question, why is it that every year more and more people are attending Silvesterchlausen, Walter Frick says: "The trend is that people want to go back to their roots. Even if it's just for an hour or a day." But which "roots" are we really longing for? Do customs have any place at all in our diverse world? Or is this precisely the time we need them? Who can partici-pate in which traditions and who is excluded?

Many customs are only partially accessible for non-locals. And women. Women are present but we stay more in the background. This ambi-valent role has something beautiful about it: it predestines for listening and observing. That's ex-actly what the four women do in this book. They set out on a voyage of discovery through Switzer-land to examine traditions and to ask questions. They provide an insight into the foreign in the own and the own in the foreign. They observe very carefully, often with astonishment, and always with great curiosity.

The most precious elements of the Silvesterchlaus costume are waiting in the barn in front of the house. The women carefully drape the shoulders of the men with the heavy cowbells and smaller round bells. They cover their faces with masks and finally put on the artfully fashioned headgear. The five figures stand in a circle and break the silence with a Zäuerli. Before the sun rises they make their way through the snow towards the village.

Sonja Enz, project manager research and creation at the Stapferhaus, attended the Silvesterchlausen in Urnäsch for the exhibition "HEIMAT. Drawing the line".

A Wild Journey

If you want to get to know Switzerland, delve into Swiss traditions. The small country is brimming with a wild variety of customs and traditions: the archaic *Tschäggättä* in the Lötschental valley, dancing pines in the Appenzell on the Old New Year's Eve, or the elaborate negotiation of cheese rights in the Bernese Justistal valley, to name just a few.

As city inhabitants we had no idea of what was going on "out there". So we traveled by train or bus to the most remote corners of Switzerland. The customs and traditions described in the book bear our personal recommendations. It is a travel guide through Switzerland and a chronicle of our favorites. The book is intended to inspire the reader to explore the country. And for those who think they know Switzerland, to discover something new there.

Two journalists, Karin Britsch and Stephanie Hess, supported us on our travels. Full of curiosity, the four of us women plunged into the world of customs where we were heartily welcomed. We met fascinating people and visited regions we had never known before. We'd like to extend a big thank-you to everyone who provided a look behind the scenes and shared with us their enthusiasm for their traditions.

For participants or spectators, the popularity of customs shows that deep within us we all harbor a need for rituals. Rituals that mourn the end of summer, that shorten the long winter and express our yearning for the spring. Hilarious customs that break the daily routine, as well as serious traditions which anchor the existing social order.

You won't have to venture far to discover the unknown in Switzerland.

Get ready for a wild journey!

Dominique Rosenmund, *photographer*
Sibylle Gerber, *author*

Silvesterchlausen

On December 31 and January 13. If these days fall on a Sunday the Silvesterchlausen takes place on the Saturday before.

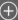

The first Silvesterchläuse set out on their *Strech* (route) around 6:00 a.m. on the outskirts of Urnäsch. After noon they can often be found in the "Tal" district, in the evening in the "Tal" and the "Dorf". In other Ausserrhoder municipalities the New and Old New Year's Eve are celebrated, too.

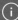

Try a *Schlorziflade* at one of the food stands. It's a delicious *Wähe*, or flat cake, filled with dried pears and cream.

The "Beautiful" and the "Ugly"

In the vaguely suggested hilly landscape slowly emerging into the light, they stomp through the freshly fallen snow, the "beautiful" and the "ugly" Silvesterchläuse. Getting up early is worth the effort, in order to be on hand for the magical mood of the New Year's wish in the Appenzell region.

Seven men stand in a circle in front of a barn door. It is no longer completely dark but not yet light and the dawn casts the snowy hills in a bluish light. One of the men begins to sing a melody in a loud, sure voice. After a few notes another begins, finds his range and accompanies the first man. The other five follow, improvising long steady notes. A deep bass provides support with his sonorous sounds. Although all sing independently, each one behind his *Larve,* the mask with the narrow slits, they all combine in a coherent whole. The result is such an intense sound that it seems as if the air within this circle is vibrating. This wordless natural yodeling is called *Zäuerli* in Appenzell Ausserrhoden.

The seven men belong to a *Schuppel,* one of the approximately 30 groups of Silvesterchläusen in Urnäsch who go from house to house wishing everyone a good New Year. Instead of giving big speeches they let the plaintive sounds of their *Zäuerli* speak for them. In between, as if to banish the magic of the melody, and everything evil from the past year, they make noise, lots of it. They hop and jump in the air, land on both feet and shake themselves, setting off the heavy bells and the smaller round *Rollen* on their breasts and backs to produce a loud racket. It echoes throughout the whole valley.

The *Schuppel* proceed in three different *Chlausen* formations. The wild dancing of the *Wüeschte* (the uglies) is especially impressive. When the giant creatures with their grimacing masks and the robes made of pine brush, straw, wood shavings or fox skins plow through the snow to the next village, they create an elemental force that seems to hearken back to a long forgotten world. The *Schö-Wüeschte* (the beautifully uglies) are the friendly siblings of the *Wüeschte,* with masks made of pine cone scales or soft moss. The *Schönen* (the beautiful) wear the more elaborate costumes. Their bright-colored velvet costumes gleam against the snow. They wear pie-shaped hoods with elaborate themes from daily life in Appenzell, covered over and over with colorful pearls.

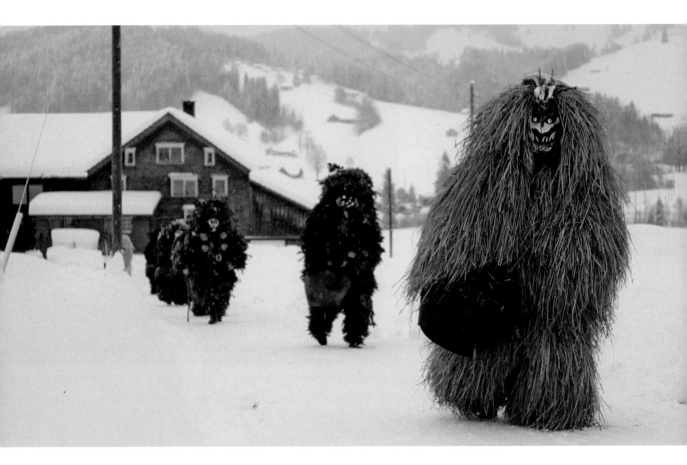

They all receive a reward for their New Year's wishes, regardless of whether they are *schö* or *wüescht*. Earlier, especially during times of war, the reward was always money. Today the families express their thanks with a hearty handshake and faces moved by emotion because the visit of the Silvesterchläuse is an honor. The Chläuse drink given cider or mulled wine through a straw for fortification. It's a long, grueling day which begins down in the valley, finishing in the early morning hours in the pubs in the village. Add to that the fact that the Chläuse ring in the New Year twice:

for the new Gregorian (December 31) and the old Julian New Year's Eve (January 13). In 1582 Pope Gregory XIII decreed a calendar reform. However, the Protestants in Ausserrhoden didn't care to be told by the Pope how they should reorganize the calendar, a tradition of stubbornness that has persisted until today.

Tradition also has it that only men wear the masks. Although there are children's *Schuppel* with girls, there are no adult female voices to be heard. When she was asked, a woman said that she could participate if she wanted to. But it would be too

cumbersome with trappings weighing up to 30 kilograms. Besides, someone has to stay home to receive the Chläuse and their New Year's blessing. And for her both days are something very special and emotional, too.

On the evening before in the living room, one of the beautiful Silvesterchläuse revealed that while singing he sometimes became "weepy". A real *Zäuerli* is something that comes from the heart. He had prepared for these two days the whole year, carving the figures for the hoods, in the evening sewing on more than 70,000 pearls with his wife and when taking the first *Zäuerli*, then it smells like mulled wine again, and childhood. This melancholy is a palpable part of the *Zäuerli*: the joy to be able to take part in the custom, the sadness about the recently deceased father who had passed on the passion for the Chlausen, or the pride inexpressible in words for the healthy children about to grow up. The old year is ushered out and something new is about to begin. Everything flows together on New Year's Eve, when it's neither yesterday nor tomorrow.

[SG]

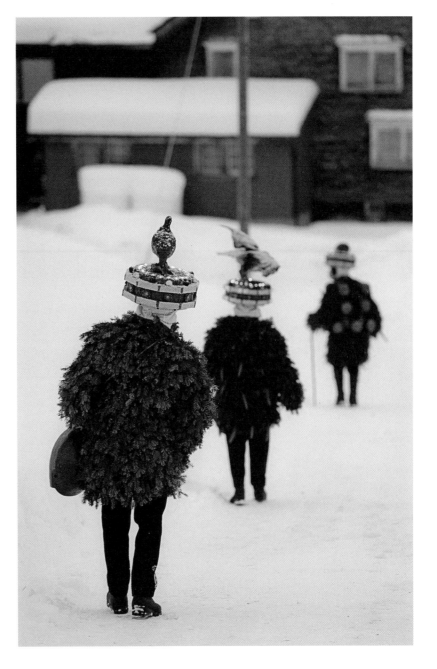

THE OLD YEAR
IS USHERED
OUT AND
SOMETHING
NEW IS ABOUT
TO BEGIN.

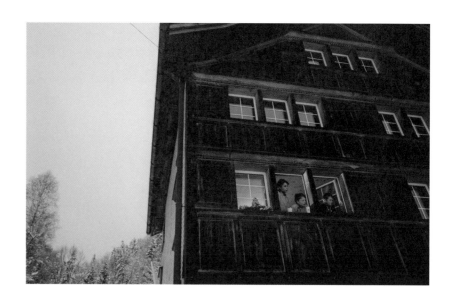

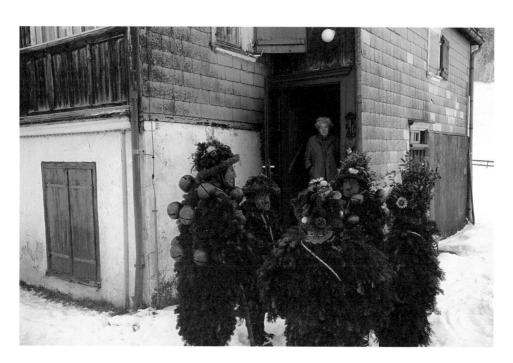

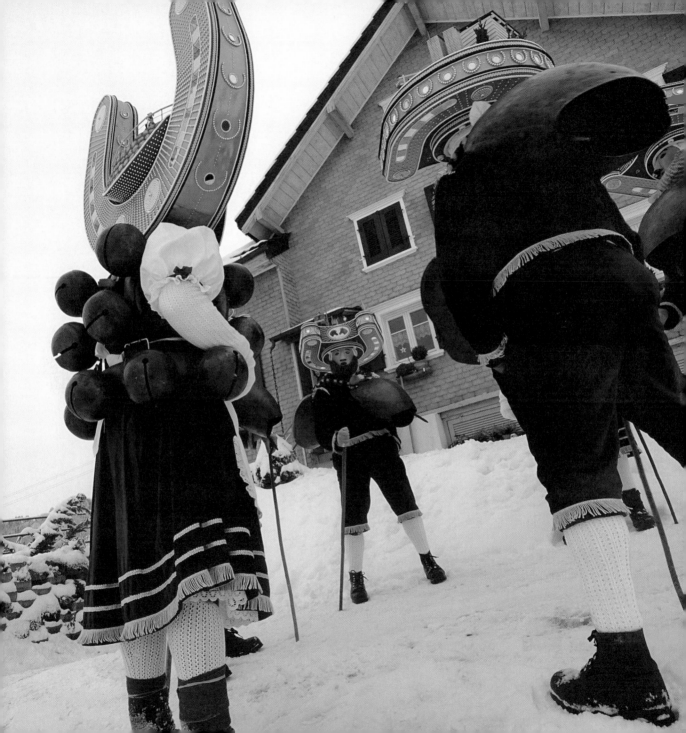

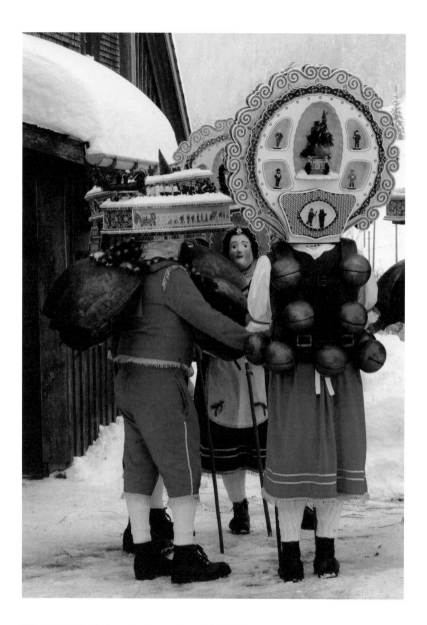
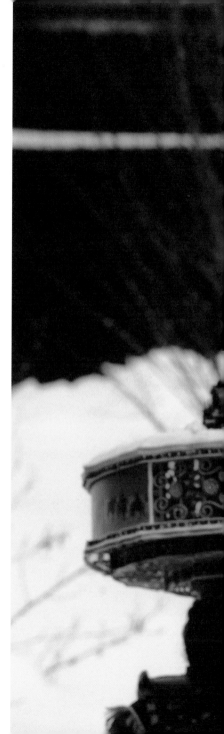

Although all sing independently, each one behind his
Larve, the mask with the narrow slits, they all combine into
a coherent whole.

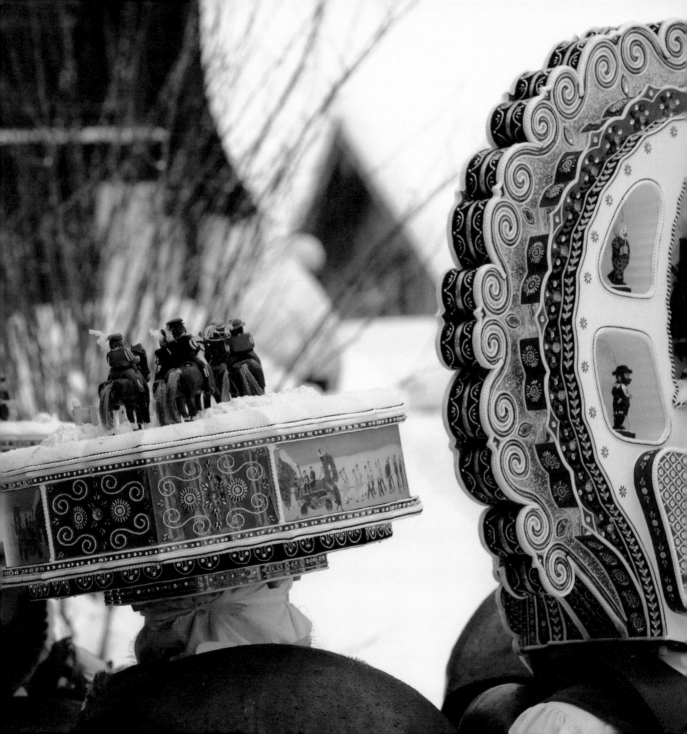

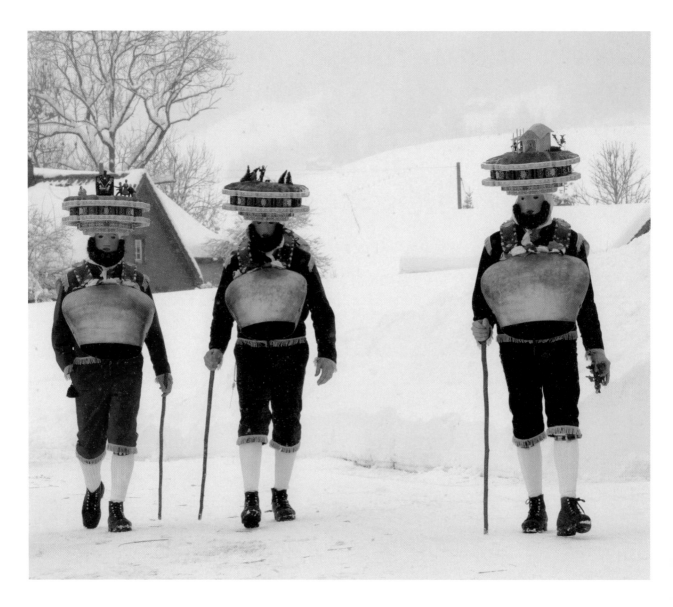

The Silvesterchläuse make noise, lots of it. They hop and jump in
the air, land on both feet and shake themselves, setting off the heavy
bells and the smaller round Rollen on their breasts and backs to
produce a loud racket.

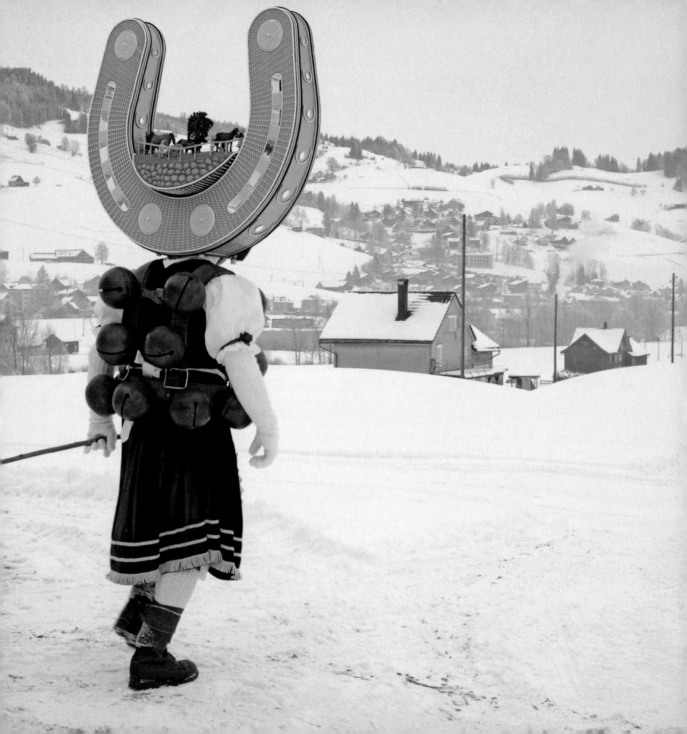

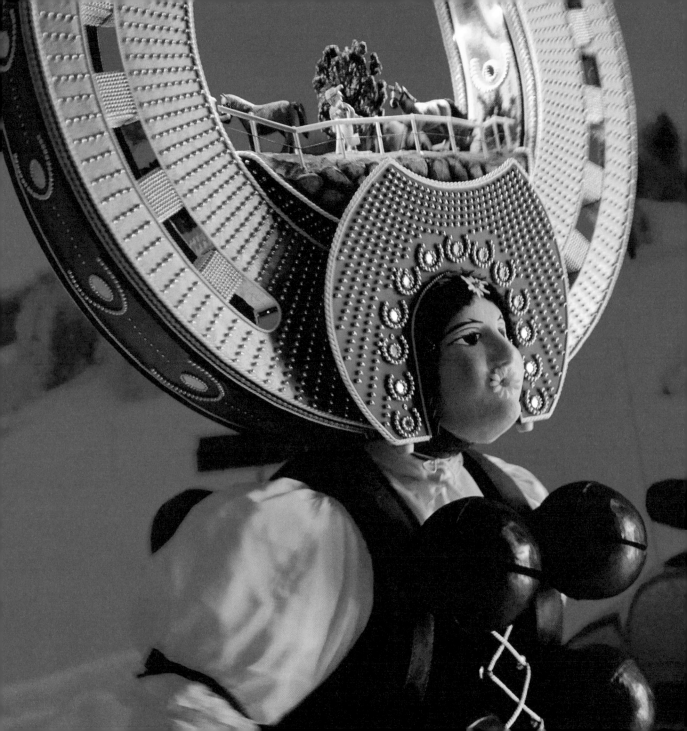

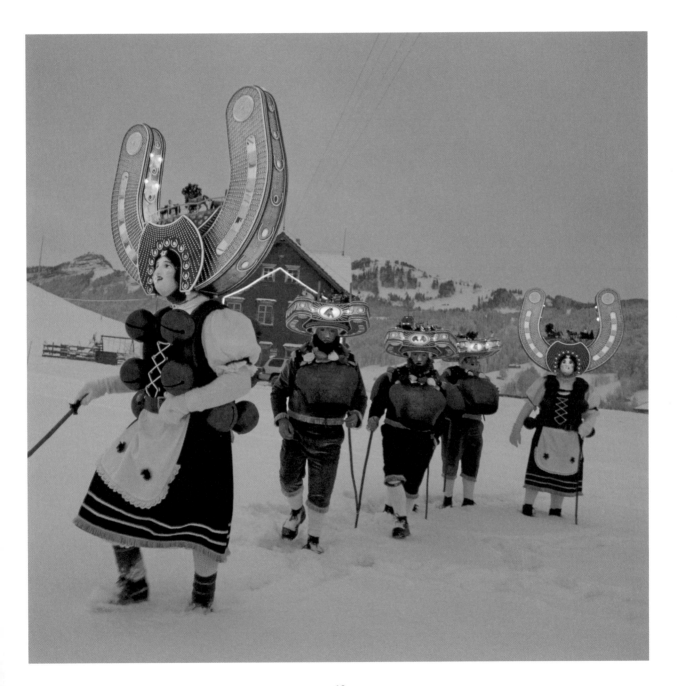

Sbrinz Route

In August

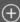

The trek starts every year alternately in Sarnen OW or in Stansstad NW.
The destination of the hike is Domodossola, Italy.

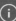

There are plenty of opportunities to greet the drivers along the route.
If you want to try to meet them on the Grimsel Pass, take the
mail van from Meiringen via Guttannen. With a little luck the already spectacular
stretch will be turned into something even more special by the
anecdotes of the mail van chauffeur.

The Drivers of Yesterday

**Live the life of a driver, for a couple of days. It's possible
to go on a trek with the central Swiss drivers on the historic Sbrinz route.
Strenuous but at the same time meditative.**

You can't miss the caravan. It winds its way up the stony path on the Grimsel Pass. 40 members, following each other step by step, dressed as if they had just stepped out of another era a long time ago. Drivers accompanied by horses, mules and donkeys. All loaded with wooden boxes and barrels. The same number of hikers in modern, colored outdoor outfit is interspersed between them, at brightly colored intervals. Just before the highpoint of the pass a whoop of joy can be heard. Daniel Flühler, the lead driver, gives the signal: "We're there!" Dozens of spectators have been waiting for this moment. They applaud enthusiastically in a warm reception for the entourage. Some spectators have traveled especially to this point in order to see the drivers. Other sightseers, on their way over the Grimsel Pass, make a spontaneous stop. The exotic get-ups are a real crowd stopper.

The caravan has been underway for three days. The journey began in central Switzerland and will end after a seven-day march along the historic Sbrinz route in Domodossola in Italy with a stupendous hello. The whole town, including the commune president and music association, will joyfully greet the exhausted participants with a festival. It is one of several such festivals, because along the approximately 170-Kilometer-long former trade route there are many stops where the drivers are greeted joyfully and celebrated in driver festivals.

In the Middle Ages salt was primarily transported on this bumping route. From the 16th century onwards, the now famous Sbrinz cheese gave the route its name. In return for salt and cheese, the drivers brought fabrics, spices and wine from Italy to the north.

Nowadays, no goods are transported on these tours. The practical wooden containers on the backs of the animals look good above all. For the eye, they are historically designed, says Daniel Flühler. They serve as a kind of handbag for the drivers. However, some of them have Sbrinz cheese with them, which is carried alternately by

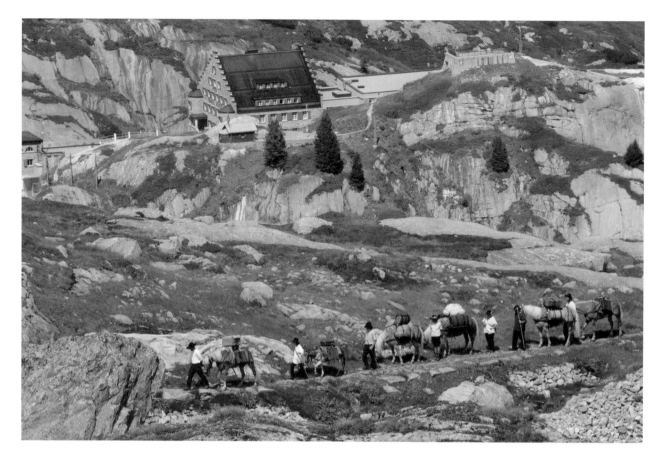

the horses. It is then ceremoniously sliced and sold at the stages in Italy. The luggage of the hikers as well as the food of the animals are comfortably transported in small trucks on the normal road. Accommodation in hostels and hotels is provided. A little luxury takes the sting out of the already strenuous route.

The success story began in 2003 at a meeting of the regulars in a pub in Sarnen in the canton of Obwalden. The discussion turned, as it often did, to the historic drivers, as co-founder Daniel Flühler explained. Through the centuries the drivers had incurred considerable risk when they traveled. They always moved in groups, for mutual protection, to reduce the danger posed by high-waymen and thieves. But the journey was still dangerous. There are many stories about that. At some point someone said, why just talk about it and indulge in nostalgia? And the wish became father to the deed.

Since then carpenters, physicians, black-smiths and clerks have put behind the day-to-day routine for a few days to take care of horses, donkeys and mules, to hike, talk with one another

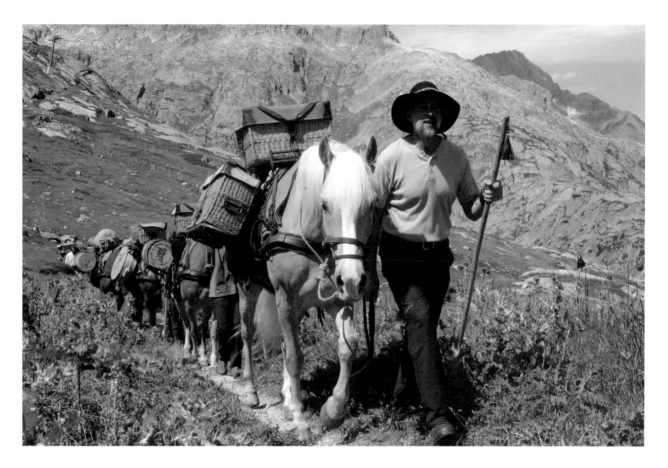

and meditate. It's a way to deaccelerate, says Flühler. The prerequisite is a short training as a driver to prove that he or she can get along with animals. But hikers can simply register. Some have returned for several years and some have had enough after one trip. Friendships have both developed and cooled off. Couples have come together or gone their own ways. A journey can unify or separate people.

Now the drivers and hikers leave as a group from the Grimsel Pass towards Valais further into the valley. The next leg of the journey is Obergesteln. After a trek of three hours, through conifer forests and past the mountain lakes, over stony grass landscapes, the group comes to Obergoms, where the prominent caravan is also met by a reception committee consisting of tourists and village residents. It's a happy reunion. Many people know each other and meet here every year. They eat, drink and celebrate together well into the night. The next morning the drivers and their escorts move on. The route over the Griess Pass is strenuous – and Italy is one step closer.
[KB]

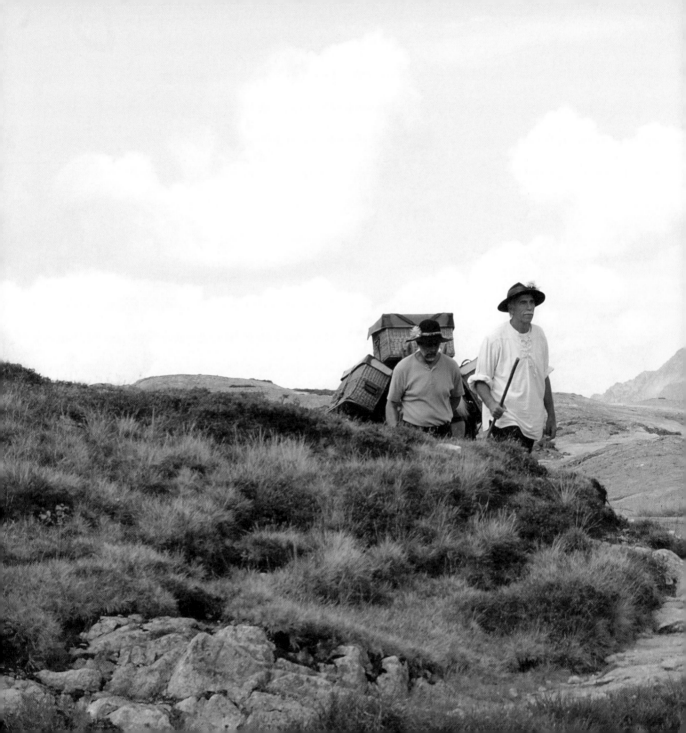

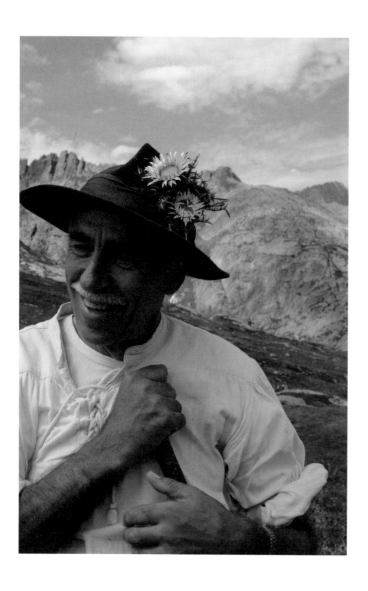

Daniel Flühler: "The drivers of that time were always observed by highwaymen and robbed again and again. Today it's easier."

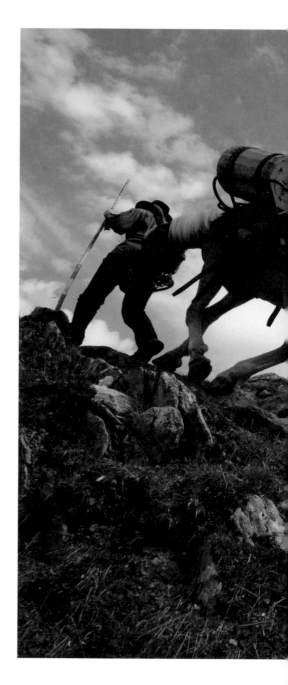

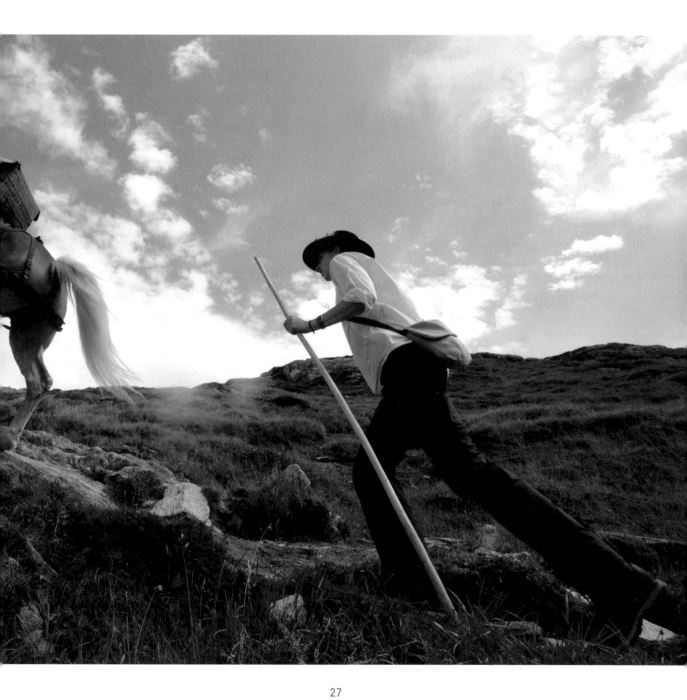

COUPLES HAVE COME TOGETHER OR GONE THEIR OWN WAYS. A JOURNEY CAN UNIFY OR SEPARATE PEOPLE.

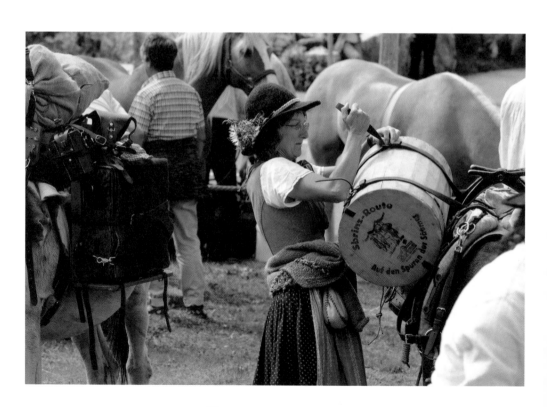

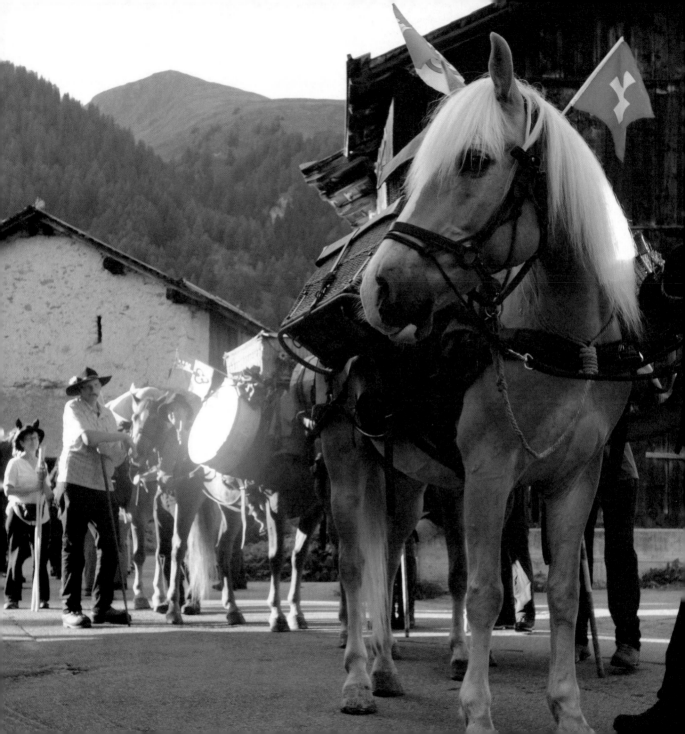

Bumper Car Prayer Service

The Basle Autumn Fair starts on Saturday before the 30th of October and lasts 18 days. The bumper car prayer service is held on the second Sunday midway during the two fair weeks.

On the bumper car ride on the grounds of the Basle Barracks. Bumper car prayer services are also held in other *Chilbis*, like those in Olten or the Wetzikon *Chilbi*.

Don't miss the *Häfelimärt* at Petersplatz square, where ceramics are offered, and right nearby the traditional booth market selling sticky *Määsmögge* and *Epfel im Schloofrogg* (apples in puff pastry) all around the two-story nostalgia carousel.

For Heaven's Sake!

The happy chaos on the bumper cars is normally the scene for flirting teenagers and parents with children in tow. For a very special tradition at the Basle Autumn Fair the bumper cars have been parked and turned into church pews in an unusual prayer service.

The fragrance of sugar and autumn spices drifts over the fairground in the morning. It is the Basle Autumn Fair which is to say it's funfair time. Right next to the operators of the stands who are busy preparing their displays of sugar-glazed biscuits and other sweet pastries, a different kind of prayer service is beginning on the bumper car. A service the churchgoers hear on the seats of parked bumper cars instead of the wooden church pews. The pastors, a man and a woman, wear shawls embroidered with carousel symbols.

Katharina Hoby-Peter, Reform pastor and her Catholic colleague, Adrian Bolzern, are at the steering wheel for today's ecumenical prayer service. They are the official ministers at the *Chilbis* in Switzerland, for the consecration (*Chile-Wihi*), or funfairs and autumn fairs, as they are also called. Their sermon is directed primarily at the showmen and the operators of the stands and amusement rides. Since that clientele is permanently on the road on the weekends in order to visit the various

fairs, the church must come to them. As a professional group whose success depends heavily on the weather, the generosity of the visitors and smooth running rides, the showmen and showwomen are apparently in no small need of heavenly guidance.

However, on this gray November morning the greater part of the prayer service visitors are among the "settled" citizenry who are taking advantage of a program in contemplative contrast to the funfair hustle and bustle. It's a special atmosphere which draws the fair spectators: in the ceiling of the bumper car hall hundreds of lights in all colors are hypnotically blinking and instead of sacral music played on organ a man plays funfair music on the hurdy-gurdy and as a filler two young female artistes play a short number.

Father Adrian Bolzern calls the showmen the "Ambassadors of Joy" in his sermon because they bring pleasure and diversion in the otherwise monotonous lives in the villages and towns of the visitors. In spite of technological advances, little

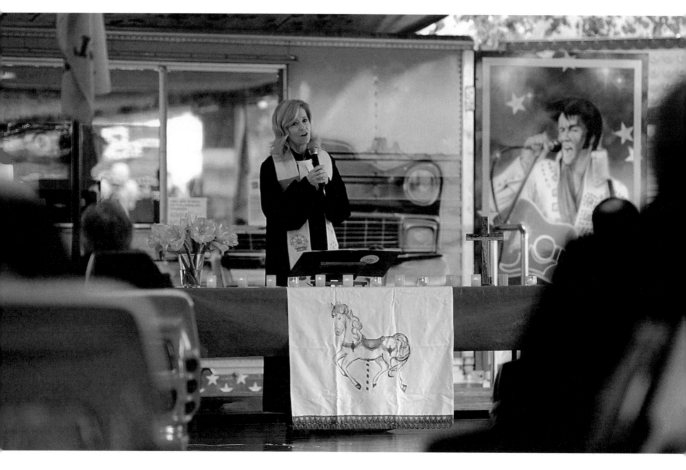

has changed in the long tradition of the *Chilbis* and the fairs. The high density of such festivals in Switzerland shows that human beings need "valves" like this. A place where the centrifugal force of a carousel can fling us into dizziness, where we can "ring the bell" with the sledge hammer, where we can eat forbidden things, like the Basle specialty *Määsmogge*, a sticky sweet candy filled with ground nuts.

In the fairs other rules are in place, which was already the case in the 15th century, when the Basle Autmn Fair was originally founded as a trade fair. During the two weeks of the fair anyone could engage in trade, even foreigners and outlaws. The occasion drew many people to the town where they were entertained by the showmen. In the commercial jargon of today one would say that the event was a clever marketing strategy for the promotion of Basle as an economic location. Staging such a fair was a privilege that was only enjoyed by a few cities. Basle was granted the concession thanks to lobby work with Pope Pius II

and Friedrich III, the Habsburg emperor. The inhabitants of Basle rung in their first Autumn Fair on October 27, 1471. This tradition is still upheld today: the sexton rings the bell in the Martinskirche church tower announcing the special two-week period. As compensation he first receives one glove. As a precautionary measure he receives the second after ringing out the fair.

The bumper car prayer service comes to an end with a blessing for the continued success of the fair and a prayer. The churchgoers slip out of the bumper car pews and the hustle and bustle outside resumes. The latest hits and loud laughter are soon to be heard in the improvised church as the cars begin crashing into each other again. This *Chilbi* is a place of extremes: the quiet and contemplative alongside the wild and ecstatic.

[SG]

Since the showmen and showwomen are permanently on the road on weekends in order to visit the various fairs, the church must come to them.

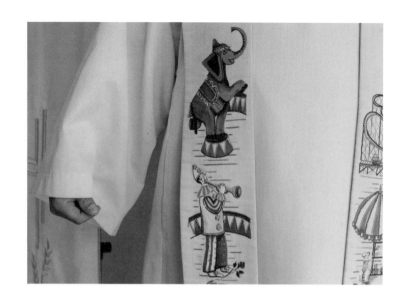

IN THE CEILING
OF THE BUMPER
CAR HALL
HUNDREDS OF
LIGHTS IN ALL
COLORS ARE
HYPNOTICALLY
BLINKING.

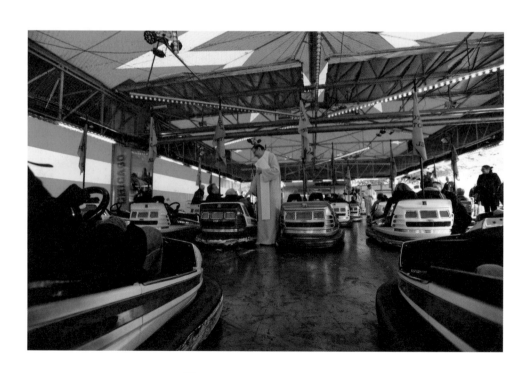

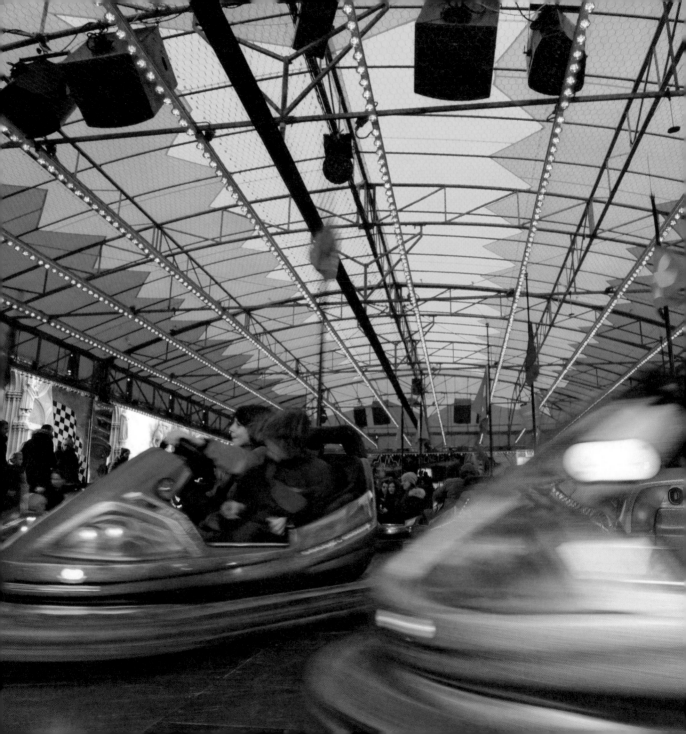

Bärgrächnig

On the first Friday in June

At the Dorfstrasse road in Adelboden

Adelboden is a gorgeous area for hiking. At the beginning of
June the mountain peaks are still covered with snow and the Adelboden mountain
railways might not be operating. A beautiful, somewhat lower lying
alternative is the *Hörnli-Panoramaweg*, a two-hour circular trail leaving from
Adelboden with a view over the whole valley and the mountain ranges.

Wall Street in Adelboden

When the Alpine grazing rights on the Adelboden Bärgrächnig
are auctioned off in a complex system, the main street in the pretty Bernese
Oberland village is transformed for one day into a stock exchange.

This tradition which has developed over years is not easy to understand. It takes place on the first Friday in June in Adelboden. Fortunately, Toni Hari, seasoned farmer and participant of the Bärgrächnig for many years, has offered to explain the complicated barter system to an uninitiated city woman. The meeting point is at 9:30 a.m. in front of the "Bären", a prettily decorated wooden chalet. This is where the farmers meet, notebook and pen waiting in their pants pockets. Some are wearing the traditional costume with the black, short-sleeved *Küher-Mutz*. All are determined to go home by midday with a place in the Alps suitable for their animals to graze in the summer.

Most of the farm families operate three-stage agriculture. They move up from the valley in the spring to the mid-level pastures, sending their herds higher up in the Alps in the summer. The luscious grass to be found there gives the milk a special taste, but does not grow forever. For this reason only a limited number of animals are permitted to graze. The Bärgrächnig regulates the users' rights.

Toni Hari takes pains to explain the mysterious system: "Let's assume you have inherited three pasture rights on the Silleren and Lurnig Alp from your ancestors. That's not enough to summer your ten cows and eight goats and on top of that they wouldn't be on the same Alp. So you go to the Bärgrächnig to see if you can swap with the other farmers and get five more cow rights, so to speak rent them."

A kind of Alpine Wall Street. Just as sophisticated, except that the trade in Adelboden is less frenetic and is completely analog: the farmers stand in groups and share handwritten slips of paper and put them in their booklets. If you look over their shoulders you will see: the slips of paper are the actual securities. They register the name of the owner of the mountain rights and the number of rights they have at their disposal.

In order to make things more complicated, the medium of exchange is in goats. One goat corresponds to 1/8 pasture right. A calf needs 2 1/3 goats or 1/3 pasture right. On the Engstligen

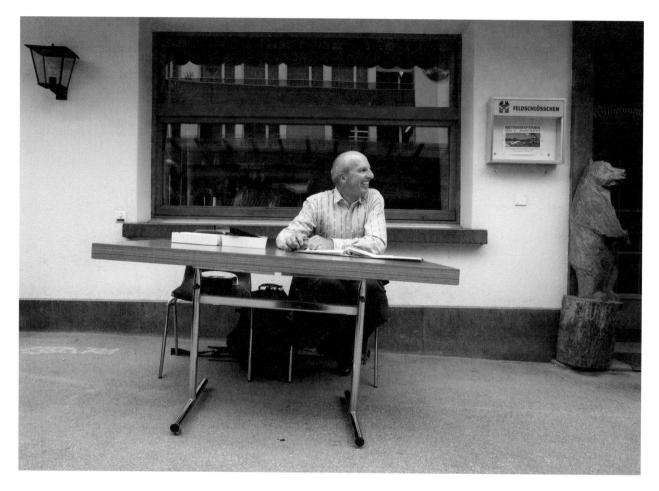

Alp there is yet another set of rules. In order to keep an overview with all this juggling with animals, one needs a sense for peasant mathematics and social fabric. Toni has his mountain receipts in order, his goat units noted in his booklet and all his animals consolidated on one Alp, while some younger farmers are crossing nervously from one group to another. Toni has been coming to Bärgrächnig for years and knows: "At the end of the day there is always enough space."

Other business is conducted in the midst of the wheeling and dealing. On the same day as the Bärgrächnig there is a large market where everything is for sale which herdsmen and others might need for the summer: one-legged milking stools, cowbells, sweets or marmot herbal salve for sore muscles. Since the whole village is on hand, other important business is conducted. Toni Hari has a meeting with the notary today. The Adelboden mountain railways want to enter into a

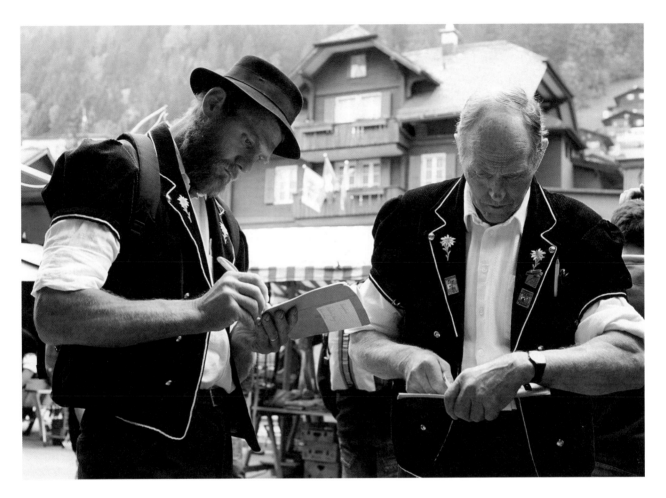

contract with the Alpschaft Lurnig cooperative for land use rights. Chair-lift pylons are to be built. Toni represents the Alpschaft as its president. The parties come quickly to an agreement, on the one side those with clean hands and white shirts from the office and on the other side those with grimy fingernails and the short-sleeved traditional costumes. Just before noon Toni has to go to the "Kreuz". The mountain bailiffs, who watch over the mountain rights, meet there in the parlors. They collect the slips of paper and check to see if everything is in order for the cows, goats and calves. Then all the swaps are recorded in a thick book called *Bergrodel*. And, very importantly: the date of the Alpine procession is established. The "bargained" animals will be on the Alps for 80 days. Until then the Adelboden farmers will have plenty to do. Toni Hari wishes for "a beautiful Alpine summer".

[SG]

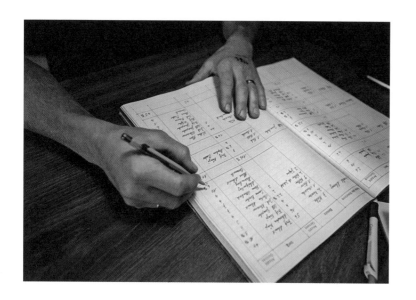

THE MOUNTAIN
BAILIFFS, WHO
WATCH OVER
THE MOUNTAIN
RIGHTS, MEET IN
THE "KREUZ".

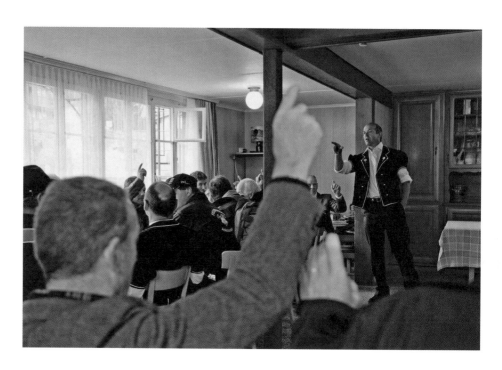

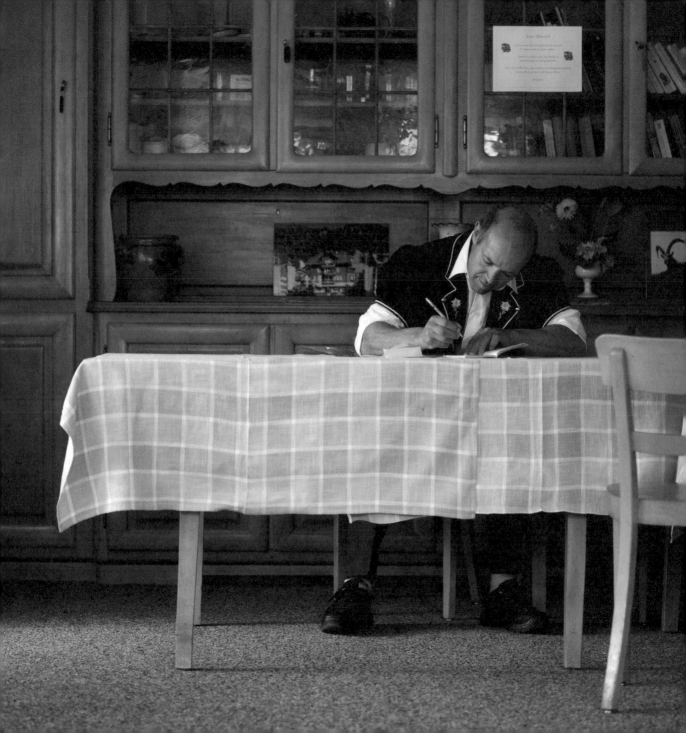

Procession des Pleureuses

Good Friday. The prayer service starts at 3:00 p.m.
and lasts until around 5:00 p.m.

In the abbey church of Notre-Dame de l'Assomption, Romont (FR)

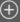

Take a walk along the circular walls of the small medieval
town. You will find a battlement walkway, embrasures and machicolations.
And the Vitromusée, the Swiss Museum for Stained Glass and Glass Art.

A Silent Cry

In the Procession des Pleureuses in Romont black-hooded women weep for the death of Jesus Christ, quietly and a bit uncannily.

A loud rattling penetrates the dark church, reverberating from the high walls. Young worshippers kneel on the ground in front of the entrance and rotate wooden ratchets, as big as rat traps. It is the ratchets and not the bells which ring in the prayer service on Good Friday in the abbey church of Notre-Dame de l'Assomption in the little town in Freiburg. The bells are silent from Holy Thursday to the Easter Vigil. As the rattling subsides, the quiet descends like a heavy veil over the worshippers in the pews. The light is dim, in spite of the strangely intense illumination of the stained glass windows, as if they were lit from behind by neon lights.

The black-clad women of Romont, the Pleureuses, quietly file into the church. They are preceded by a man, symbolizing Jesus, with a great wooden cross on his shoulders. The crowd seems to shudder collectively. Behind him come the quietly weeping women with a measured pace. They wear floor-length robes and black scarves over their faces, fastened on their heads with pins. They are carrying ominously red cushions decorated with the instruments of martyrdom of Jesus: the thorn of crowns, the scourge, nails, a hammer, pliers and the symbolic veil of St. Veronica. The veil which Veronica extended to Jesus to wipe the blood and sweat from his brow as he carried the cross on his way to Golgotha, the hill where according to Christian belief the Son of God was crucified, leaving the image of his face in the cloth.

The story of the Passion of Jesus as told in the bible is also the subject of this prayer service. The mass held in French tells the story of how Jesus was betrayed by his disciple Judas, condemned to be crucified, scourged and forced to carry the cross to which he was then nailed on Golgotha. At this point in the story, the Pleureuses and the bearer of the cross get up and slowly leave the church, entering into the bright early spring light. The introverted sadness and the heavy black scarves on their heads all seem out of place on this carefree spring day. The sky is blue and nature is

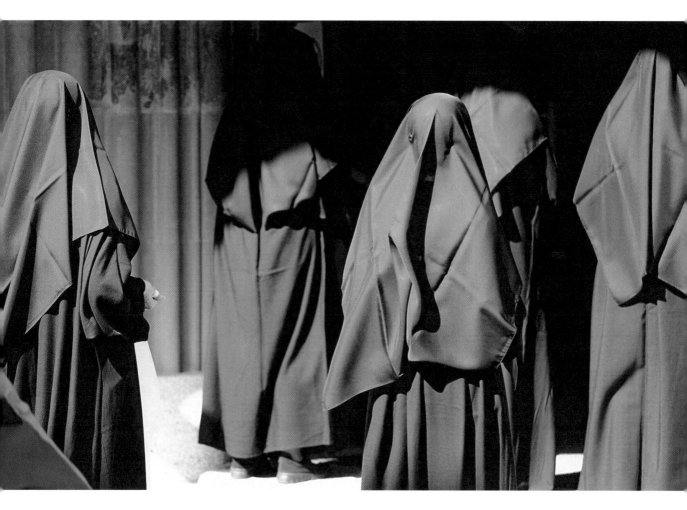

awaking everywhere, the trees are budding, the luxuriously green meadows are radiant in the distance, dotted with the yellow of the dandelions.

The priests, altar boys and the faithful follow the black-clad women whose robes and scarves are now billowing in the gently breeze. The church choir sings on, their song transported outside by loudspeakers. In 14 stations, which symbolize Christ's way of the Cross to Golgotha, the proces-

sion now circles the church: it stops when prayer and song begin, and continues in silence. In this vivid representation of the bible story the custom of the Pleureuses refers to an old tradition from the 15th century. The words of the bible long recited in Latin are now spoken in the vernacular to make the story understandable for the faithful.

Someone coughs, a child giggles. Every sound outside this oppressive ceremony seems

unnaturally loud, including the clicking and whirring sounds of the cameras belonging to the amateur photographers swarming around the black-clad figures. They seem aggressive, the way they focus on the reverent tableau of women. In order to not disturb the procession a laminated sign has been posted in French, English, German and Italian on the church door requiring the photographers not to cross the procession out of religious respect.

Today the custom, which almost disappeared in the 1970s, seems to have taken on a new life along with the hordes of photographers, although the Christian belief can hardly be said to play a leading role in the lives of most Swiss citizens. The faceless and uncannily profound earnestness of these women seems to reach out from the past centuries and captivate people even today.
[SH]

The introverted sadness and the heavy black scarves on their heads all seem out of place on this carefree spring day.

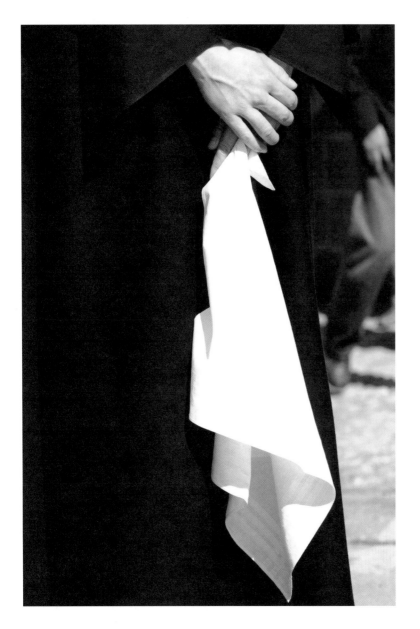

Someone coughs, a child giggles. Every sound outside
the oppressive ceremony seems unnaturally loud.

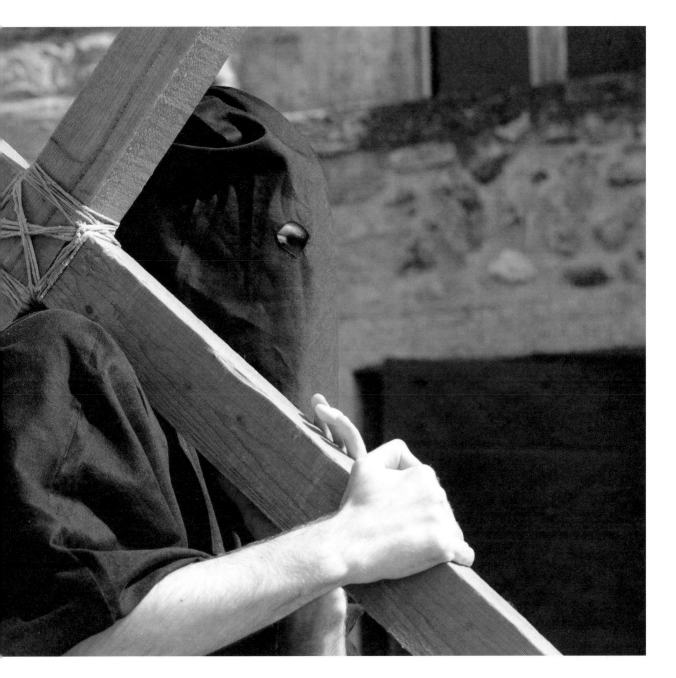

Bärzeli

January 2

Hallwil in Seetal, canton of Aargau

Beginning at 11:00 a.m. In the schoolhouse an aperitif is
served for the Hallwil residents and invited guests.
The concluding *Spaghettiplausch* with coffee and cake in
the gymnasium is open to the public.

Dancing Pines, Pungent Bliss

You can forget about the quiet on the Berchtoldstag holiday in
Hallwil. Masked figures dash through the village spreading fright and merriment.
The effect is bizarre and absurd, but at the same time festive and funny.

Please no hugs. If the *Stächpaumig* outstretches his arms, run away as fast as possible. If you get caught you will itch, sting and be bitten everywhere. But the encounter will bring you luck. And who doesn't want to be lucky? Especially for the New Year.

It's the 2nd of January, or Bärzelitag (Bärzeli day). The Aargau municipality of Hallwil is in turmoil. Jumping piles of wood shavings, a lurching camel, driven by a beater and a rider, both dressed in white. 14 weird figures zip through the crowd in front of the schoolhouse. Some are armed with a *Söiblootere*, a pig's bladder prepared by the butcher especially for the Bärzeli festivities. They wish all those who cross their path good luck with a whack or two on their backs. And there's quite a few of them. About a fourth of the 800 souls from Hallwil and another 800 gathered from outside the town. The old and the young go at it with abandon, or just patiently let it happen. After all, the point of the custom is to bring people luck.

The Bärzeli have been celebrating loudly and colorfully for 150 years. The custom is documented to have begun in Hallwil in 1858. It has been celebrated in the current form since 1950. What is the message? As is often the case with such customs, that's not an easy question to answer. It's definitely intended to increase the fertility of nature and to drive out winter. There are the green figures that represent the fertility of spring, while the emaciated ones symbolize the barrenness of winter. Among the green figures in addition to the itchy holly there is the *Tannreesig*, which looks like a dancing pine. He wants to hug everyone, unlike the *Straumaa*, a figure made of straw, the *Hobuspöönig*, a fat one made of wood shavings and the *Schnääggehüüslig*, an irregular figure strewn with thousands of empty snail shells. The three represent the cold, stagnation and silence.

Those aren't the only ones running around in costume. There are figures which depict light and shadow, the transitory and new life. The white *Herr* and the white *Jumpfere* radiate beauty and youth, and the man covered with playing cards, the *Spielchärtler*, imparts the zest of life. In contrast the *Aut*, a bent-over old man, is dark and used-up.

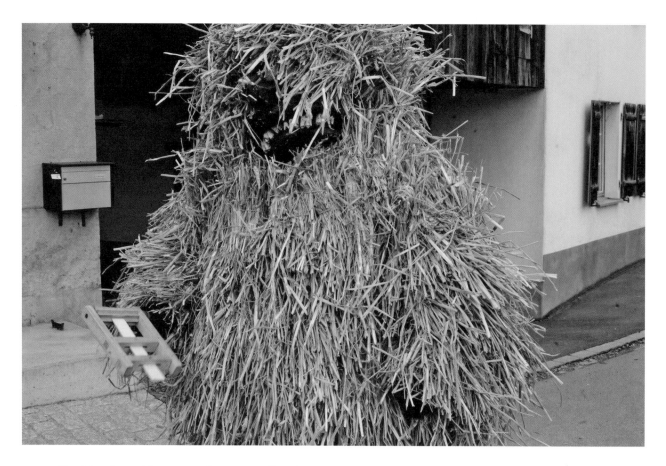

The *Lörtsch*, an old woman, who supposedly splashes fertility water from her pan, devotes herself to no less than the progress of life. Fertility aside, she soaks the one or the other passing by.

Many of these figures have a small-scale counterpart: the little Bärzeli, the school children. They are perfectly aware of what they have to do. They occupy the square in front of the schoolhouse early on, roaming about, impudently hitting grown-ups without fear of consequence. They only differ from the larger figures because their blows aren't so vehement. And girls can participate; among the grown-up figures women are still taboo. In many customs women were not or are not permitted to participate because often the men want to make an impression on the women. Today the Hallwil custom simply ushers in the New Year and is practiced as such. Those who want to participate have to belong to a village club and have the energy and stamina to keep up.

After the figures have romped around, the caravan moves through the village accompanied by scores of villagers. That's where the Bärzeli are provided with food and refreshment. But woe

to the spectators who have no alms or pocket change for the Bärzeli cash box. In a friendly manner they are chased, splashed with water, bear-hugged and some land on the ground, disappearing beneath a straw or fir-tree man. By the way, nature herself provides everything that goes into the costumes. Every year 10 to 20 planks are sacrificed for the imposing *Hobelsspänig*. Those who wear the costumes make them by themselves. The local costume group takes care of those without perishable material.

About an hour and a half later the Bärzeli tour ends where it began, in the gymnasium. At first this is not exactly the place to quietly enjoy coffee and cake. The berserkers take over the hall, dancing on tables, tipping over peacefully chatting men and women from their chairs. Hardly anybody minds. It looks like everyone had just been waiting for the storm because only after the Bärzelitag has been celebrated and the berserkers have run riot does the New Year really begin in *Haubu*, as Hallwil is called in local dialect: Well then, good luck!
[**KB**]

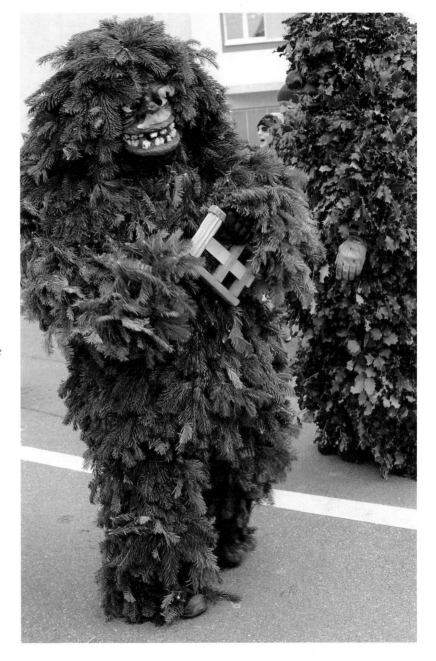

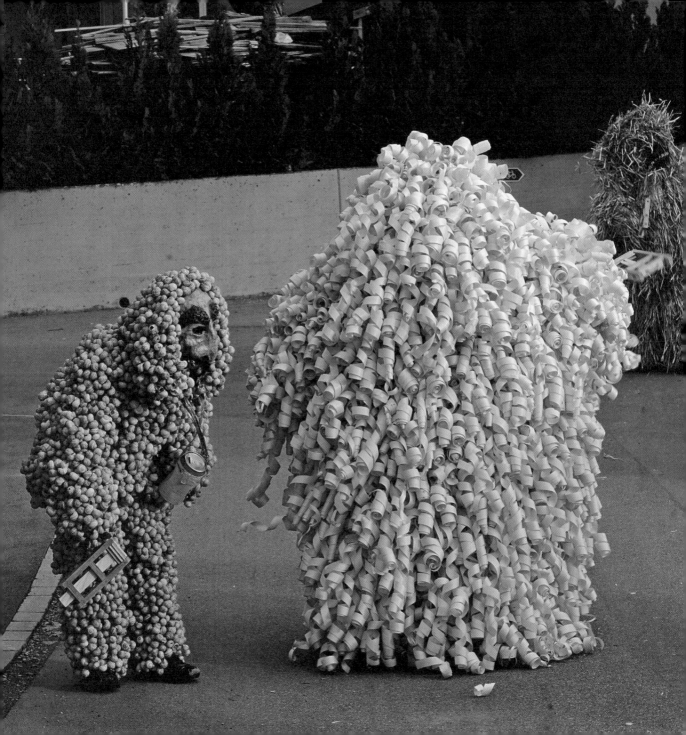

THEY HUG
SCRATCH, BITE
AND PRICK. BUT
THEY BRING
GOOD LUCK.

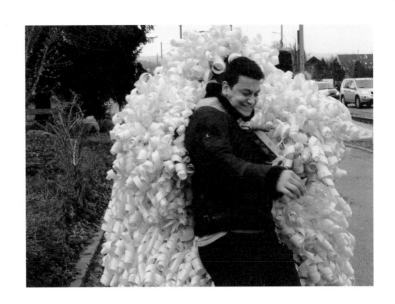

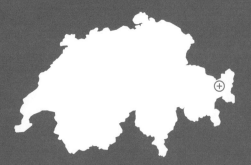

Chalandamarz

On March 1st. In some villages, as they do in Guarda, the children already
march through the village with bells on February 28.

Many spectators observe the Chalandamarz in Guarda because that's where tradition
has it that Schellenursli was born. But the custom is celebrated in other Engadine regions as well,
like Münstertal, Bergell, Puschlav, Misox, Oberhalbstein or in Albulatal.

Hotel Meisser, located in the center of Guarda, maintains a Schellenursli museum,
where the pictures of the book are lovingly reconstructed.

Ring Loudly, Speak Softly

The children in Guarda in Grisons drive out the winter from the alleyways and houses. It's a custom which became known around the world thanks to a little boy.

The Chalandamarz is probably the Swiss custom that is best known around the world. The picture book story "Schellenursli" about a boy and his bell was translated into dozens of languages, including Mandarin, Arabic, and Esperanto, with several film versions so that the ringing ritual of the bell procession to drive the winter from the alley and houses every March 1st became famous worldwide.

It goes like this: Ursli sheds large tears when he sees the tiny bell he is given to participate in the bell procession in his village. So he makes a secret decision: he struggles through the deep snow to the Alpine Maiensäss belonging to his parents where a giant bell is hanging. He falls asleep on the hay bed, exhausted by the ascent, where he is protected by animals. His parents become frantic and the whole village looks for the lost child. The next morning the boy strides through the snow back to the valley with the giant bell. Now he is allowed to lead the procession of the village children as the bearer of the biggest bell.

The houses in Guarda look exactly like the ones in the picture book written by Selina Chönz and illustrated by Alois Carigiet here in 1945. Huge wooden gates as doors, decorative paintings on the walls of the houses, small windows which look like they had been cut out of the thick masonry. There are scrape marks and paint remains on the corners of some houses from the automobiles that didn't make it through the old alleyways originally built for narrow horse-drawn carts. The smell of wood stoves hangs in the air as it begins to snow.

The visitors are slowly assembling in the alleyways. Many are holding cameras, single lens reflexes or smartphones, the dangling protective covers swaying back and forth. The 20 boys who march along in the bell procession make their way slowly through the village. They are wearing red pointed hats on top of faces screwed up in concentration. The image is just too good not to be captured: children with red cheeks in front of old houses. Change and nostalgia in one picture.

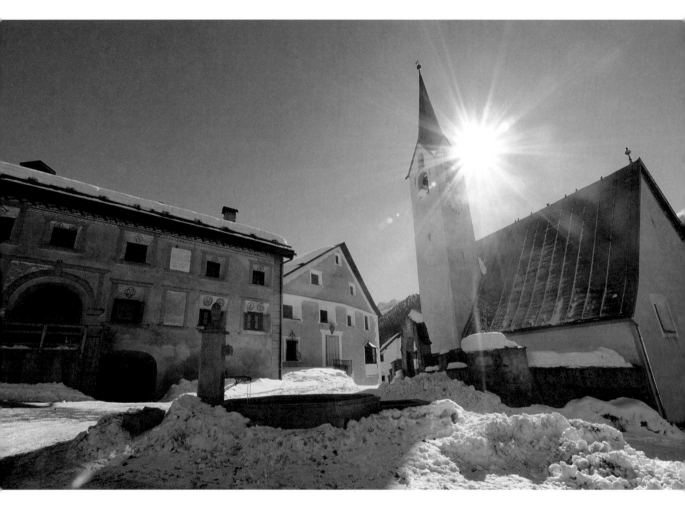

The boys hold their hands under the cowbells or goat bells in order to keep pace with their steps. The eldest with the largest bell with the diameter of a good-sized pumpkin leads the way, followed by the smaller children with bells the size of apples. Then, one of the huge wooden gates opens and they disappear inside, one after the other: They ring out the winter and the nasty spirits from the alleys and the houses as well.

Most of the children in this procession don't live behind these old walls in Guarda. At the end of February they come from the canton capital of Chur and the rest of Switzerland specially for the Chalandamarz. Their parents grew up here and take them to the rehearsals in order to keep alive the ritual. One of them is Richard Bickel. Today his three daughters are at the Chalandamarz. He says: "We want to help

keep this custom alive. Why? It's balm for the soul."

Like the other girls, his three daughters don't march in the bell procession. They wear the red-and-black traditional Grisons costume and stand in the archway of the old houses. The boys put down the bells, join the girls and in those children's voices that go right to the heart they sing: "Chalanda Marz, chaland' Avrigl, laschè las vachas our d'uigl... la naiv svanescha e l'erva crescha." In English: "The first of March, the first of April, let the cows out of the barn... the snow disappears and the grass starts growing." They stand behind a cart with a milk can in which the spectators throw coins. A small contribution for the young people.

Then the girls help the boys to pull on the *Plumpa*, the leather straps on the bells, over their shoulders. The ringing starts up again: on to the next well, into the next house. The snowflakes slowly color the roofs of the houses white: Winter is not over yet.

[SH]

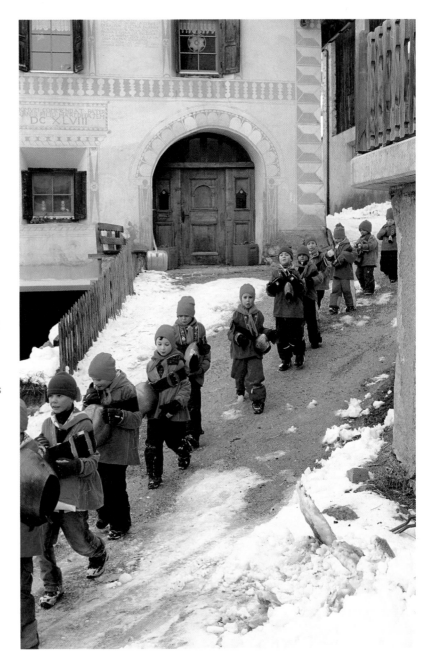

Children with red cheeks in front of old houses. Change and nostalgia in one picture.

The boys put down the
bells, join the girls and sing
in those children voices
that go right to the heart.

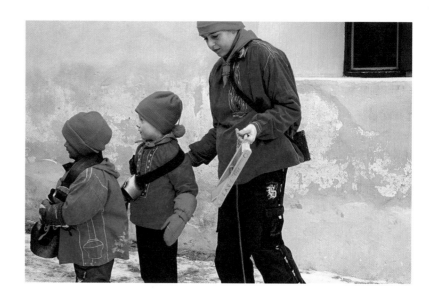

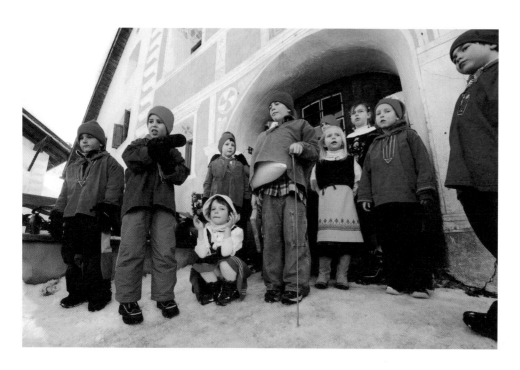

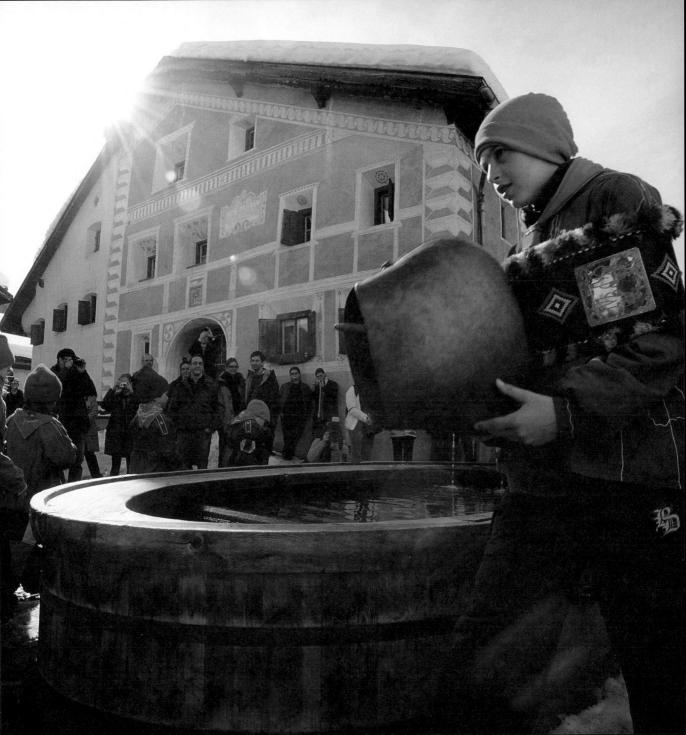

Chestnut Festival

The chestnut festival always takes place at the end of
September or beginning of October, the chestnut beating in November.

Bergell, canton of Grisons

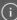

Try the chestnut bread and the typical stew, Bergell chestnuts with bacon.
Bergell is also a hiking paradise throughout the picturesque villages.

From Bread for the Poor to Delicacy

The little brown one is the queen of Bergell. The sweet chestnut is much more than an edible chestnut. It brings family and friends together, is as much a feature of the region as the mountains and is the star of the chestnut festival.

You can see and smell the smoke from afar. It billows from small fires. They line the way from Castasegna to Bondo, the picturesque town in Bergell, plunged into tragic notoriety by the avalanche in the summer of 2017. A farmer burns the bulky leaves from the chestnut trees. One pile after another. A strange noise rings out a few hundred meters further, a popping sound. What is it? The scene closer up is even more astonishing: several men, women, and children are slapping cloth bags on blocks of wood. Not from anger, actually quite festively. As they explain to me, those are chestnuts in the sacks. They're beating the dried chestnuts.

If you travel to Bergell in the fall, you can't overlook the chestnuts. They are part of the scene, hidden behind the Maloja Pass on the Italian border. Like the unique dialect, the *Bargajot*, which sounds like a mixture of Italian and Rhaeto-Romanic to those who cannot understand it. It was the home of the artist Alberto Giacometti and the painter Giovanni Segantini often came here in the winter because of the special light conditions.

That's what people said, but maybe he just liked the mighty chestnut trees, standing densely packed in a triangle between Castasegna, Soglio and Bondo. In an involved process several thousand kilograms of chestnuts are harvested here every fall. It's a process that takes time. Nature has lots of that. Depending on the wind and rain the chestnuts fall off the trees at the end of September, sometimes with their entire thorny shell. Shaking the gigantic chestnut trees is out of the question. Therefore, the owners are forced to make their rounds, day after day.

The most beautiful specimens are sold to individuals and small shops. Sometimes some of the fruits end up in the pots of persons selling sweet chestnuts. The less magnificent chestnuts are dried and stored in small drying huts, called *Cacina* by the locals. It smells like smoke here, too. The brown fruits are kept here for five to six weeks. They lose their moisture on a narrow grating over a smoldering, never open fire. That way they avoid decomposition and greedy mice. When the chestnuts are dry, they can be beaten.

Some families have been recently relying on hand-made machines to replace the manual labor. But this technological advance has not caught on because beating the chestnuts is also a family celebration. Children, friends and acquaintances come home to help, all hands are welcome. Even tourists and curious onlookers are allowed to roll up their sleeves and pitch in with the strenuous process. Sometimes music is played, or the helpers sing. Whatever is agreeable is allowed. The only thing that remains constant is the beating: three handfuls of chestnuts in the sack, 30 blows, then comes the pop, and the chestnuts shed their dry brown shells. What remains is a light brown fruit, the core. They are shaken once again in a *Van*, a mighty wicker basket, stirring up a lot of dust and shedding the last remnants of the shell. The rest is done on the kitchen table at home, surgically precise, by hand with a knife. The fruits are then packaged in small bags, sold and sometime later softened in water, cooked and eaten.

By the way, after being imported by the Romans the chestnuts became a main source of nutrition in the otherwise barren, steep terrain,

which aside from the southern climate and flair had little to offer. The chestnuts were considered the poor man's bread. Today they are much more, a specialty which is used in the production of everything edible. They are the stars of the festival whose name it bears. Everything one might wish to know about the little brown fruits can be learned here. There are tours through the chestnut forests, podium discussions about sustainability, climate change and the effects on the chestnuts. One can learn how chestnut bread used to be baked, take home recipes, follow the footsteps of Giacometti and Segantini; take a tour back in time. Every conceivable delicacy is offered at the chestnut festival: chestnut pies, chestnut soup, chestnut pasta dishes, chestnut schnapps and even chestnut beer is served.

A sumptuous sociable open-air picnic usually rounds off the chestnut beating days, or in the coziness of indoors. Those who help out are fed. The cold, the dust and the sweat are forgotten and exchanged for rosy cheeks and beaming faces. It's all part of a vital tradition.
[KB]

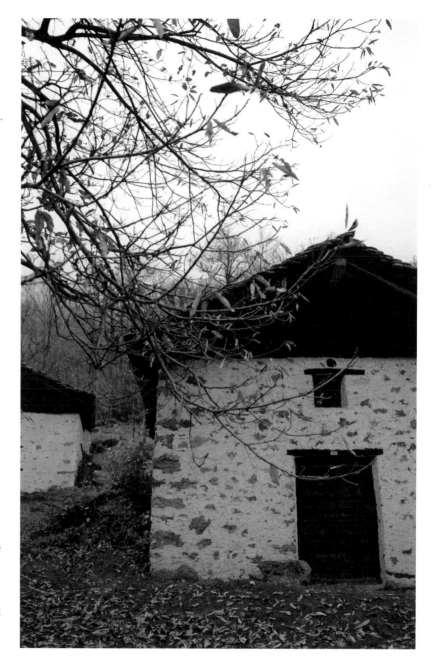

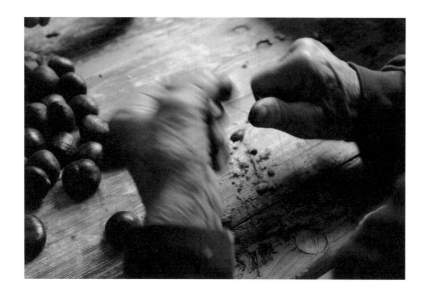

Whoever can, helps out.
There is a lot of manual
work involved in the chest-
nut harvest.

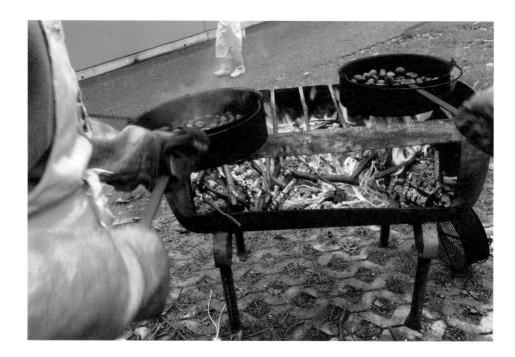

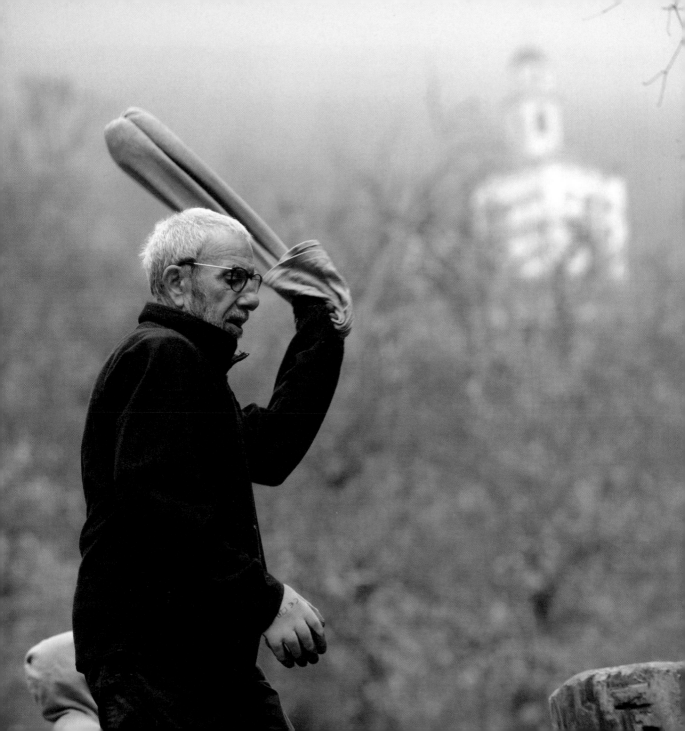

THE CHESTNUT
BELONGS JUST AS MUCH
TO THE BERGELL AS
THE UNIQUE DIALECT.

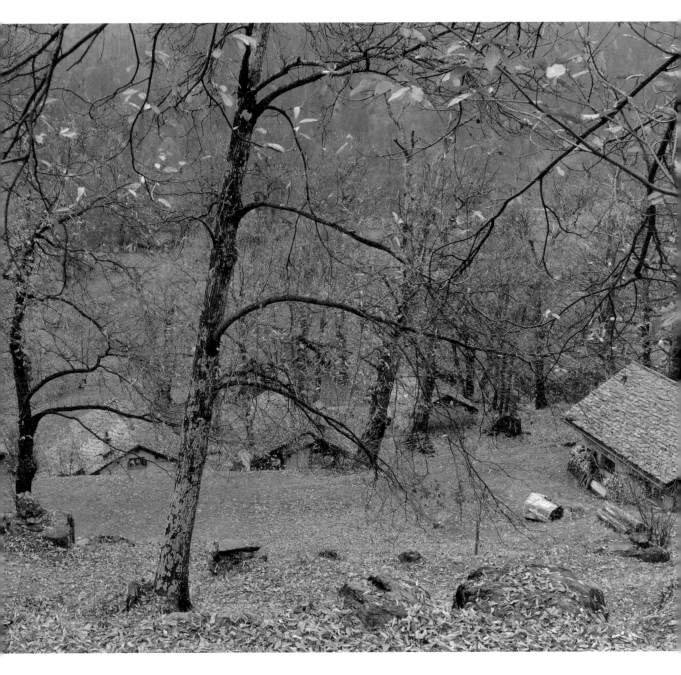

Chienbäse

On the first Sunday of Lent, the first Sunday after Ash Wednesday.
The procession begins at 7:15 p.m. and lasts about 90 minutes.

The route goes from the Burgstrasse, Törli, Rathausstrasse, Rebgasse,
and Gerbergasse streets to the lower Gestadeckplatz square.

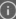

Buy a sticker and support the Liestal carnival.

It is recommended to wear old, fire-proof clothing because sparks occasionally
fly during the procession. Small children are not permitted to be carried on the shoulders of
adults in the crowd because the heat is greater at shoulder height.

On the morning after take the special train to Basle: the Basle Carnival starts on Monday
at 4:00 a.m. with the *Morgestraich* (reveille) and is just as mystical.

Subdued Fire

Liestal downtown barely survives a disastrous fire every year.
That's when at the highpoint of the Liestal carnival the burning
Chienbäse are carried through the narrow alleyways.

It's pitch black on this cold February night in the Liestal *Stedtli* (old town), the Sunday after Ash Wednesday. All streetlights are switched off, the residents have turned off the lights in their downtown apartments and are leaning expectantly out of their opened windows. An excited dense throng is waiting below in the alleyways for the highpoint of the Liestal carnival, or *Lieschtler Fasnecht*: the fire. Not just because it brings warmth and illuminates the little village again, but also because the procession with the burning Chienbäse is so dangerously beautiful.

At first the fire behaves itself. The procession begins with the Liestal carnival cliques, the drum and piccolo sounds of the music groups and the lanterns with satirical political subjects. The fire is caged behind brightly painted screens. The precision of the cliques marching in rank and file utterly breaks down as the first groups bearing the wildly blazing Chienbäse torches on their shoulders make their approach.

But the word "torch" can't convey the impression they make: with up to 100 kilograms the Chienbäse are more reminiscent of Finnish candles with their thick, broom-like bundled wood splints. The brooms are called *Chien* because they are made from pine, a resin-drenched wood that burns especially evenly. Although the custom seems archaic, its history "only" goes back to the year 1800, when the sources refer to a great carnival fire and a torch procession outside the city. Beginning in 1924 the Chienbäse procession in its modern form was introduced.

The flames of the Chienbäse crackle and the bearers groan beneath the weight and the heat. Most of them are wearing fireman's helmets with neck protection, others have slipped a metal catch basin on their heads as protection against the falling pieces of burning wood and glowing sparks. One is roasting a *Klöpfer* (cervelat sausage) on his helmet. Fortunately, along the procession real firemen cool off the backs of the Chienbäse bearers with wet towels, or simply dump a bucket of water on their heads. The air sizzles and steams.

And then it is there, the truly monstrous fire. The dark sky behind the city gates becomes

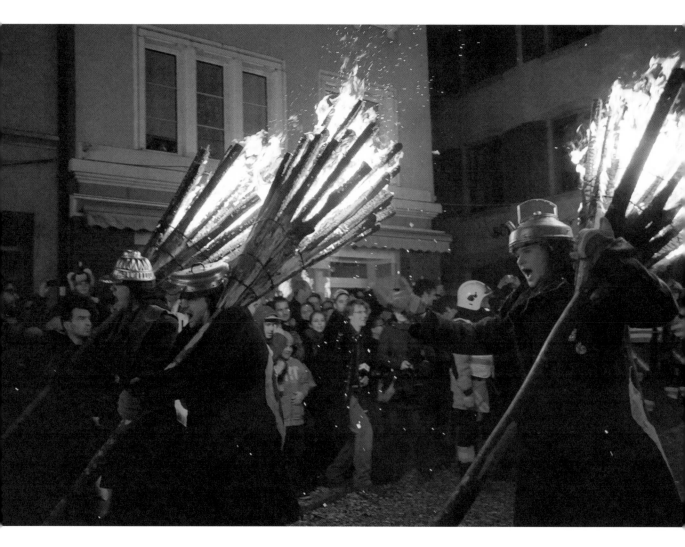

orange-red, the sparks rise up to the rooftops. An excited murmur goes through the crowd: How is this fire going to slip under the gate without plunging the old town center into a sea of flame and laying it in ashes? The carts full of blazing sticks of wood actually set the tower on fire for a short period of time. But luckily the wood-clad interior has been soaked down just before-hand. As the carts move past the crowd of specta-tors the comfortable warmth becomes an almost unbearable heat. The spectators are forced to seek cover. Those who can, retreat to the house walls or take cover behind another spectator. Front row seats have lost their attraction.

Tongues of flame often lick dangerously close to the old town houses. The reflection of the windows doubles the effect. Fire, heat and smoke are everywhere. Although it all seems to be under control, one can feel the danger that emanates from this element up close, but at the same time one enjoys the warmth that is often missing, especially in winter. As with other customs involving fire it's intended to drive away the winter symbolically. At least in the old popular imagination. But maybe it is just the joy in watching the infernal spectacle in this dreary time of year. In this cold February night in Liestal the message is abundantly clear: "Disappear, old man winter! Bring on the spring." [SG]

The flames of the Chienbäse cradle and the bearers groan beneath the weight and the heat.

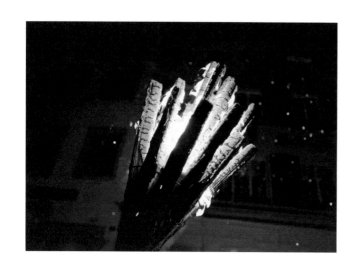

THE DARK SKY
BEHIND THE GATE
BECOMES ORANGE-
RED, THE SPARKS
RISE UP TO THE
ROOFTOPS.

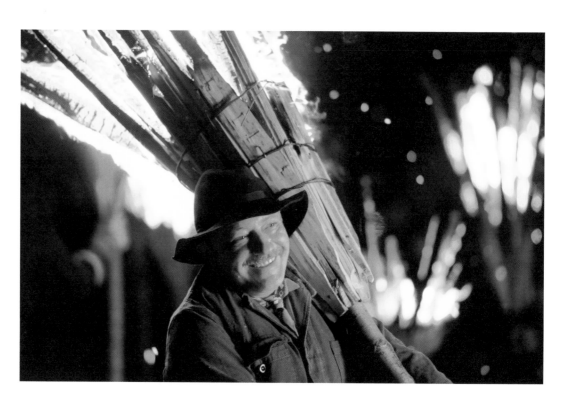

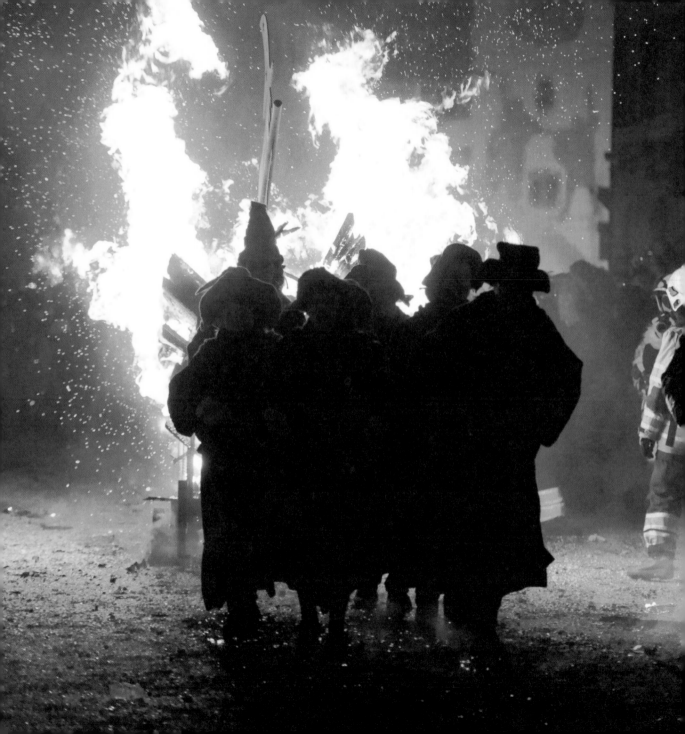

Herens Cow Fighting

The Herens breed National Finals take place on a weekend of the first two weeks in May. In spring and fall there are an additional eight sparring qualification festivals in smaller arenas in Upper and Lower Valais.

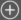

In the Arène Pra Bardy near Aproz in Sion. Shuttle buses leave from the train station in Sion.

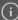

Sausage made from Herens beef or raclette, cut directly from the cheese loaf, are available on the festival grounds. Raclette also works at spring-like temperatures: for the real Valaisans raclette is a summer dish, best served with a glass of Fendant, the fruity Valais white wine.

"La Reine des Reines"

**They battle from spring to fall, the mighty Valais Herens cows.
They fight to see which of them has the final say on the pasture. The Valaisans
take advantage of this inborn fighting spirit and bring the strongest
cows to the National Finals in Sion, where the "Queen of the Queens" is crowned.**

The massive Herens cow named Miracle stands apparently disinterested in the ring, with the white start number on her flank. She slowly approaches another cow, rolling her head in the grass and scraping her hooves in the dust. Suddenly, from one moment to the next, the battle begins: a collision of 600 kilograms masses each. It's a brutal sight when two broad heads bash against each other, their upwardly twisted horns interlocked like mountain bike handlebars. But it is not just strength that determines victory. Tactic and endurance play a role, too. It can't be excluded that Miracle from the lighter weight class displaces the heavier cow. At any rate, her owner, one of the few women, is hoping for a miracle.

Those who watch the combats need time and optimally a good camping chair in the bleachers, because the cows in the ring pick out their opponents themselves. And time is of no interest to them, which is why a duel can last up to 15 minutes. For instance, when two heavily breathing cows keep up the fight and neither wants to give up. The battle continues until one of the two turns away. If a cow

loses three times, it is excluded and must leave the arena. From the loudspeakers, in two languages comes the command: "Evacuer le numéro 25, s'il vous plaît! Nummero 25 bitte *abfiehru*", meaning "Number 25, please leave the arena". Now the job is to make that clear to the female giant in the battle of her life. Nothing less is at stake than her status as lead cow and it will take some pushing, shoving and some good persuasion on the part of her owner to convince her to leave the ring.

Cow fights of the robust Herens breed take place during the first pasturage in spring on the Alp. Or at the big events: every year up to 15,000 spectators visit the National Finals in the beautiful arena framed by the steep craggy cliff in Sion. Approximately 150 animals fight there.

The breeders have invested much time and passion in their cows. Most of them keep Herens cows as a hobby, because in comparison to the high-performance cows the Herens yield too little milk or meat. On this holiday, the Final, half the owner's family is on hand, cheering their cow on. They take a

Those who watch the combats need time and optimally a good camping chair in the bleachers.

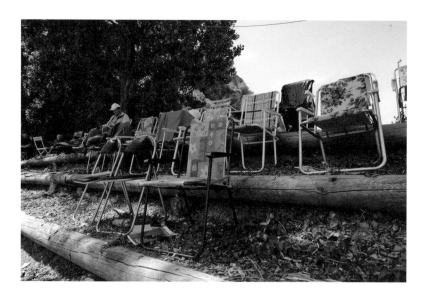

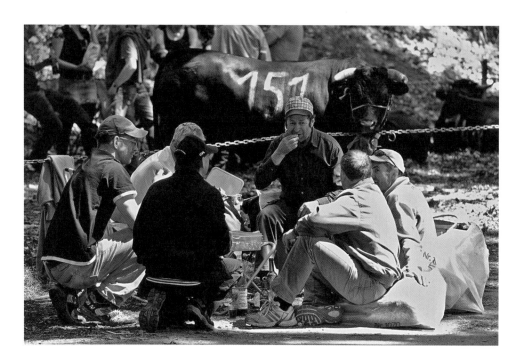

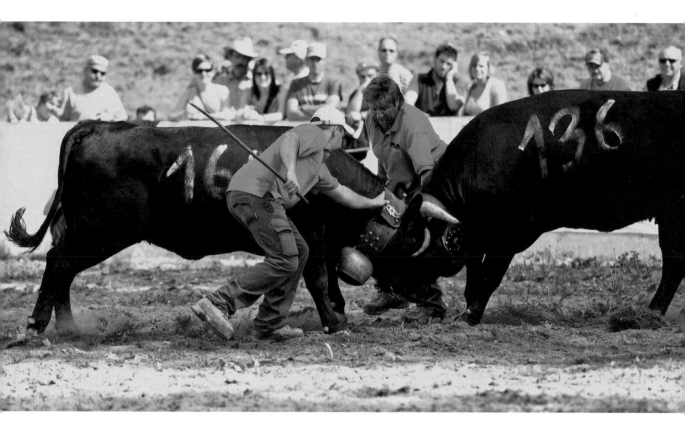

comfortable break in the shadows of the high poplars, Tupperware stuffed with sandwiches are making the rounds with some of the good Valais Fendant wine to calm the nerves of the excited breeders. Their cows stand quietly by them, almost like members of the family, enjoying a back rub in their dark fur and relishing the endearments whispered in their ears. The close connection of the breeders with their animals is palpable. Becoming the "Queen of the Queens" means a substantial increase in value, not to mention the fame and honor.

These cow fights are not without their critics. Animal rights activists consider the practice a misuse of the animals for public entertainment.

But the responsible parties point out that there are hardly any serious injuries during the battles. The cows lock horns that have been carefully ground down as a precautionary measure. And if things get too rough, the brave *Rabatteure*, nimble drivers, step in and separate the cows by yelling and shoving. And if a cow doesn't want to jab, or to fight, then that's fine, too.

This year Miracle just missed pulling off a miracle and the crown went to another cow. But she leaves the combat as a victor in her class. And for her owner the black behemoth is still the favorite cow in the barn.

[SG]

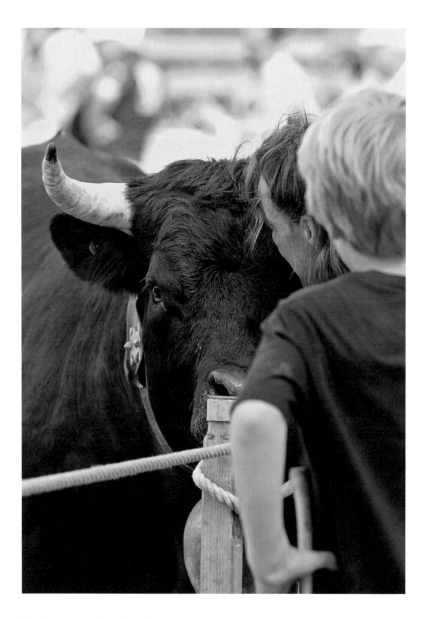

The close connection of the breeders with their animals
is palpable. The cows get a back rub in their dark fur and
whispered words of endearment in their ears.

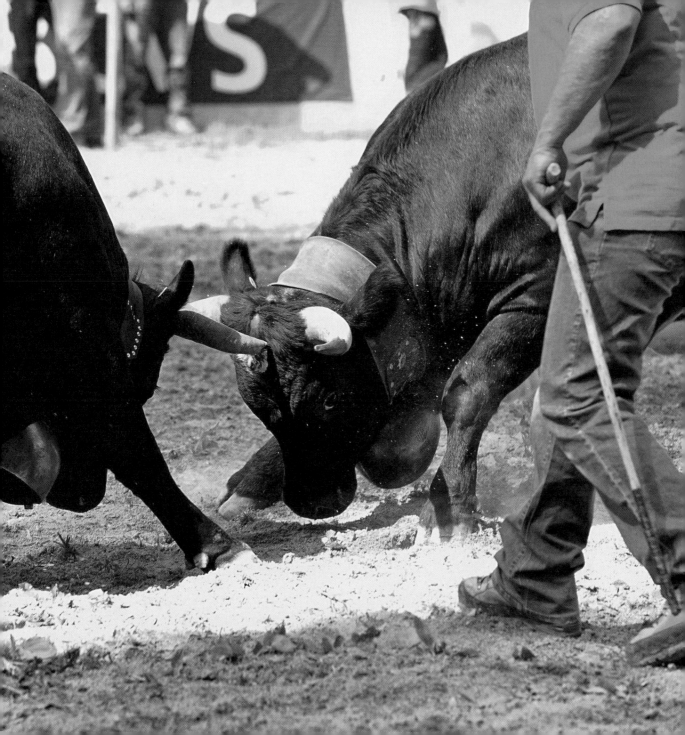

Fête des Vendanges

On the last weekend in September

In the old town of Lutry

A beautiful hike through the wine terraces
of Lavaux: from Saint-Saphorin to Lutry, 11 km,
approximately three and a quarter hours.

Intoxicating Views

**The right time for a foray into the Lavaux wine
growing region near Lake Geneva is during the golden light of fall.
Lutry celebrates the end of the harvest with a folk festival.**

It could also be an ocean. This majestic lake that never seems to end, and on which the train is running along now. If one looks out the window to the left, there it is, gleaming, Lake Geneva, the largest stretch of water in Switzerland, framed by the peaks of the Alps. To the right the vines are rushing by, like contour lines on a topographical map standing up erectly along the steep range of hills. It's hard to decide on which side to sit on the train ride along the lake.

The approach to the Fête des Vendanges in Lutry is part of the experience. The route follows the northern bank of Lake Geneva, in the midst of the Vaudois vineyards between Montreux and Lutry. This is the wine growing region of Lavaux designated by the UNESCO as a World Cultural Heritage site. Already since the 11th century the steep, wild hills have been terraced for wine-growing. However, it is not exactly an easy area to cultivate. The maintenance of the stone walls and the care of the vines is only accomplished with heavy manual labor. But it seems to pay off:

the direct exposure to the sun, the reflection from the lake and the warmth stored in the stone walls allow for a mild microclimate, producing wines from the Lavaux that are especially fine. The triple sun is the key.

The trek by foot through the wine villages is even more beautiful than the journey by train. So upon arrival, the first glass of Chasselas (Gutedel) is more than deserved. On the last weekend in September, in this medieval town dotting the lake, the grape is celebrated. The Fête des Vendanges is the grape harvest festival at the end of the harvest season. And drinking the local wine is a must. After all, the wine from the past years must be appropriately appreciated, too. In the alleyways of the towns and on the quay the many *caveaux* (wineries) operated by associations and companies offer the Lavaux wines. The Chasselas is the most common wine type. Chardonnay or red wines like Pinot Noir are less often cultivated in the region.

Since eating and drinking go hand in hand on festivals like this one, the obligatory food stands,

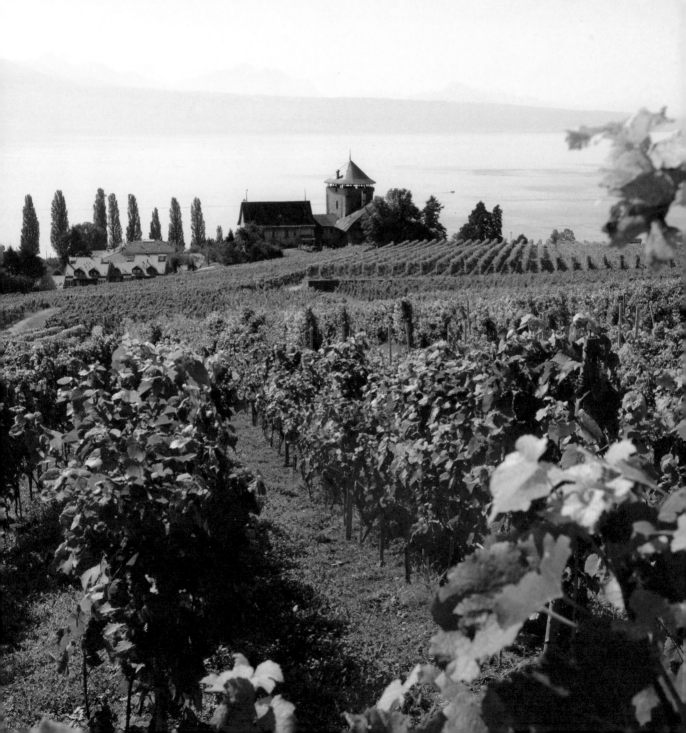

festival benches and various concerts are also part of the Fête. And there is something for the children, too: on Saturday afternoon there is a paper chase for the 5 to 12 year olds. But the actual highpoint for the citizens of Lutry is the children's procession on Sunday when approximately 600 school children from Lutry march past in costumes for this year's theme through the *bourg*, the town. The proceeds are donated to the *Colonie des Vacances*, a mountain chalet where the children of Lutry can spend their summer vacation.

Meanwhile down in the town a folk festival mood prevails. If quiet is preferred, one can climb up into the hamlets of Lutry, to Savuit, Le Châtelard or Corsy. High up in the hills to the vintners, whose preparatory work makes this festival at the lake possible. With a little luck one can get a glimpse in a wine cellar and a glass of young wine. Together with the seasonal help drawn from across Europe, they drink to the conclusion of the harvest time with the wine of last year. The wine is a delicious stimulant for the visitors to the Fête. For the vintners the juice of the grape is their livelihood.

Along with Lutry many other towns in Western Switzerland as well as other wine regions in the country celebrate the harvest time in the fall. The festivals vary in size from smaller wine tastings like *Ligerzer Läset-Sunntige* (Ligerz at Bielersee lake) to the giant festival of the *Fête des Vignerons* in Vevey which is only celebrated every 20 to 25 years. Regardless of where the festivals are held, the reason is the same: maintaining the culture of local vintners and reveling in the harvest abundance before the end of the luxuriant season. [SG]

Down in the village a folk
festival mood prevails.
If quiet is preferred one can
climb up into the hamlets
of Lutry, to the vintners.

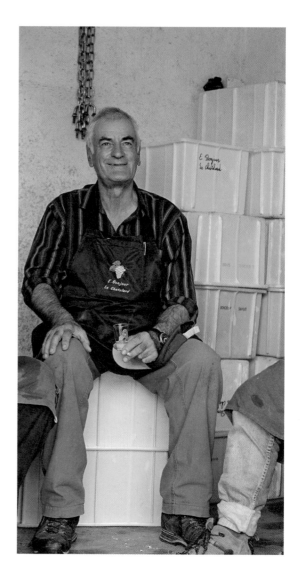

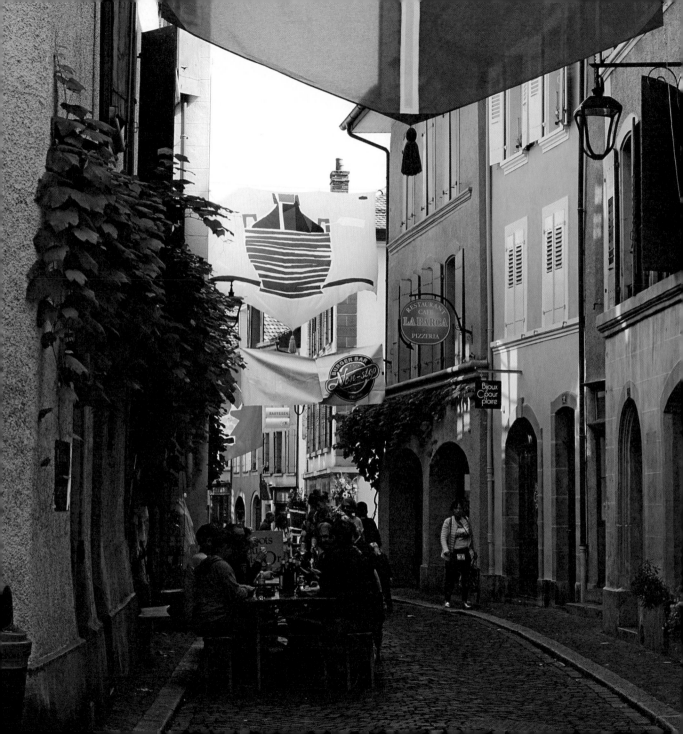

Kästeilet

At the end of the Alpine summer, usually the end of September. Exact dates
can be found on the website of the Sigriswil municipality.

Justistal near Sigriswil and Mägisalp near Hasliberg in the Bernese Oberland

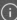

The end of September in the mountains can be rather cool,
warm clothing is the order of the day.

The Pleasure of Shared Joy

**Before the cows depart from the Alps in
the fall, the Justistal farmers receive their wage.
It is paid out in large, yellow loaves.**

Summer is over. The thick fog wrapped around the peak of the Spycherberg Alp on this September day makes that clear. Wisps of songs and thin streams of tobacco smoke rise up from the moist air. The Justistal farmers are celebrating the 300-year-old tradition of Kästeilet along with the end of summer with a lot of tobacco, white wine and polyphonic yodeling. Many visitors from the cities are also on hand on the green meadow. Their brightly colored multifunctional jackets provide a stark contrast to the elegant, shimmering black herdsman frocks with their puffed sleeves.

The farmers here are paid back in the special currency of what their cows have produced during the last months on the Alps: the Justistal Alpine cheese, not to be confused as a seasonal product with the mountain cheese produced all year round. It is not the only precise terminology, which means something here. In the final analysis it's a business proposition. For one cow which spends the summer on the Alps a farmer needs a mountain permit. In one summer a cow on the

Alp produces approximately 800 liters of milk, which constitutes a lot. The exact amount of milk a cow produces and how much cheese that yields is meticulously recorded. That becomes the basis for the farmer's allocation.

The visitors gather around the wood huts, which are called *Speicher* (magazines) here. Long planks are set up in front of it. The farmers are there, standing in a row. As the gnarled doors are opened, the heavy aroma of cheese seeps out. Loaf after loaf swings from one farmer's big hands to the next. The last farmer in the crew stacks the wheels of cheese in towers of equal size that look like giant yellow wedding cakes. There is a minimum of talk in favor of singing. Musicians bend Swiss accordions, *Schwyzerörgeli*, over their thighs, farmers and visitors join in with their voices in different pitches. It is a musical farewell to the summer. One drinks white wine in transparent plastic cups and eats plaited bread with a dark crust and cheese. The products come from the farmers' carts decorated with flowers which later,

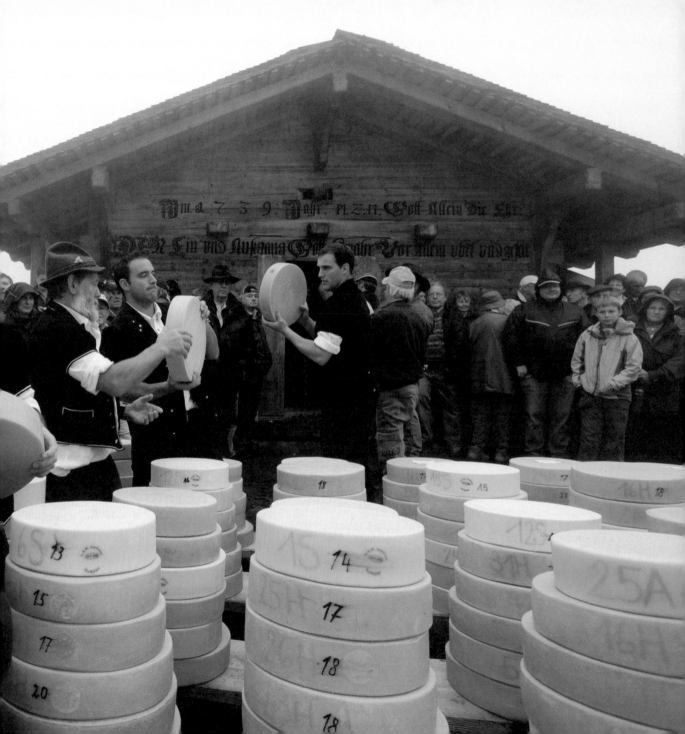

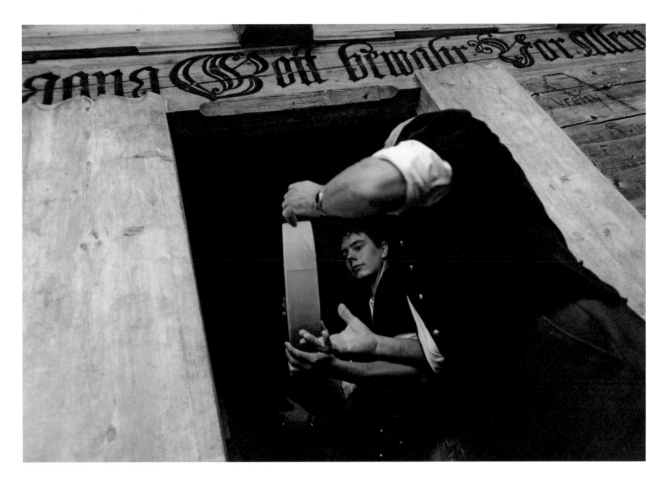

loaded with cheese, are transported with small tractors back to the valley.

Now all loaves of cheese are in the open. The farmers draw lots for the stacks of cheese. Little wood sticks, so-called *Brittlein*, with the family names are dumped into a little sack. One after another is drawn, called out and placed on a stack of cheese. Some stacks have several such name sticks, which means that the stack has to be divided in a pre-announced proportion. No one needs to pull out a knife. Instead of being divided, the loaves are allocated according to agreement. Then the cheese is loaded on the carts.

With their allocations of cheese the farmers and their cows depart from the Alps, led by the cow that produced the most milk that summer. All that remains in the Justistal are the closely grazed meadows, empty magazines and a couple of cow flaps on the paved streets. And of course the fog that will creep down to the valley in the weeks to come.

[SH]

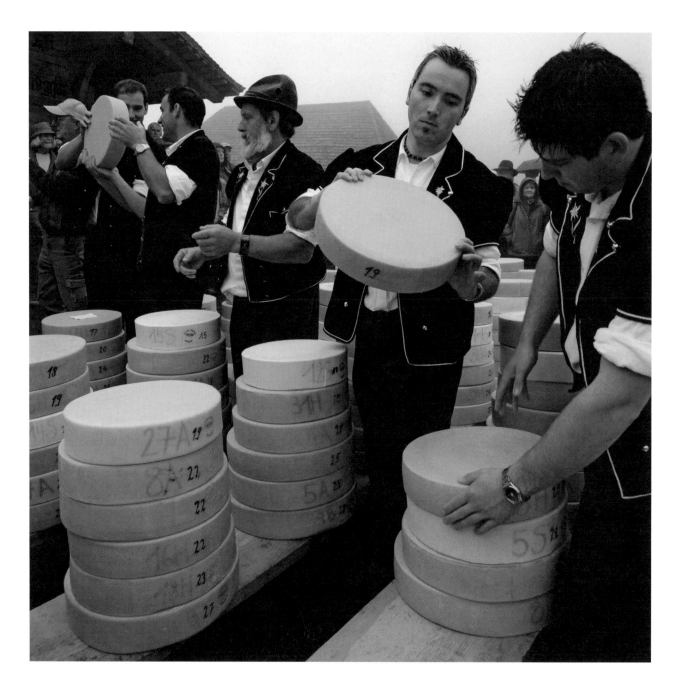

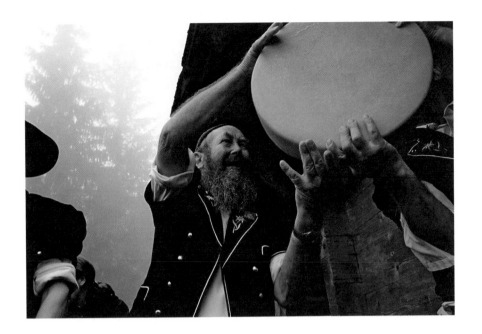

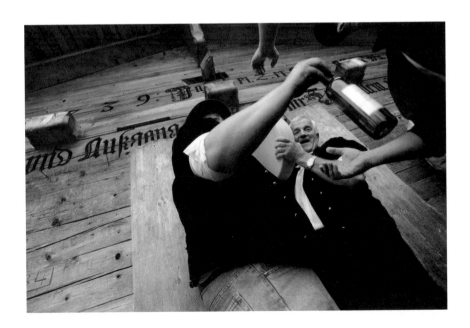

As the gnarled doors are opened, the heavy aroma of cheese seeps out. Loaf after loaf swings from one farmer's big hands to the next.

Landsgemeinde

Always on the last Sunday in April

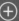

Appenzell, Landsgemeindeplatz square, about five
minutes from the train station

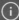

Landsgmendchrempfli, a pastry with hazelnut filling and
traditionally baked for the Landsgemeinde, are sold. All restaurants
are open and there is an assortment of food stands.

April is capricious: one can get a sunburn or catch
a cold. Check the weather report!

Free to Speak

A tradition with a lot of joy, but also a
serious side. It's more than a festival. It is a state-supporting
event, in which individuals merge as a people.

It could be *Chilbi* or a village festival in Appenzell. Cool bottles of white wine with a light film of condensation are standing on festival tables set up in the alleyways. The sun is shining, there's a smell of roasting sausage, hot cheese or the aroma of manure wafting over to the village from the meadows nearby.

People are dressed in their Sunday best. Beneath their clean shaven faces the men wear suits and ties. The women are wearing discrete summer skirts and slightly heeled shoes, their freshly washed hair glistening in the sun. And in addition to the joy evident on all the faces, there is a touch of earnestness, rooted in the venerable feeling of civic duty, participation and a deep trust in democracy. What happens here on the last Sunday in April is in fact no *Chilbi*, no festival and no party. It is a state-supporting event going back hundreds of years: the Landsgemeinde (cantonal assembly).

Today in addition to Glarus, Appenzell Innerhoden is the only canton which still holds a Landsgemeinde. Since 1400 all eligible voters in the canton have annually met (since 1991 including the women) in order to determine the coming financial expenditures, projects and new personnel in the government and in the canton court. They do this in public by raising or not raising their hands. In the rest of the Swiss cantons this kind of polling is no longer the basis for a gathering, but conducted either by mail or at the ballot box.

People are standing tightly packed together and leaning out of the windows at the edge of the narrow main street leading to the Landsgemeindeplatz in the center of town. The brass band begins to march and play, festively and beautifully. They are followed men swinging flags in rich, dark colors over the heads of the spectators. Then come the members of the government with a rocking step, and the judges. At a very slow pace. They are wearing black coats, billowing in the gentle wind.

When they reach the Landsgemeindeplatz they ascend the wood bleachers, on the "chair". In front of them are the citizens, cordoned off by ropes. The entrance is guarded by men, who wear bright gold helmets. Here, the individual merges with the whole. They become the people. Many

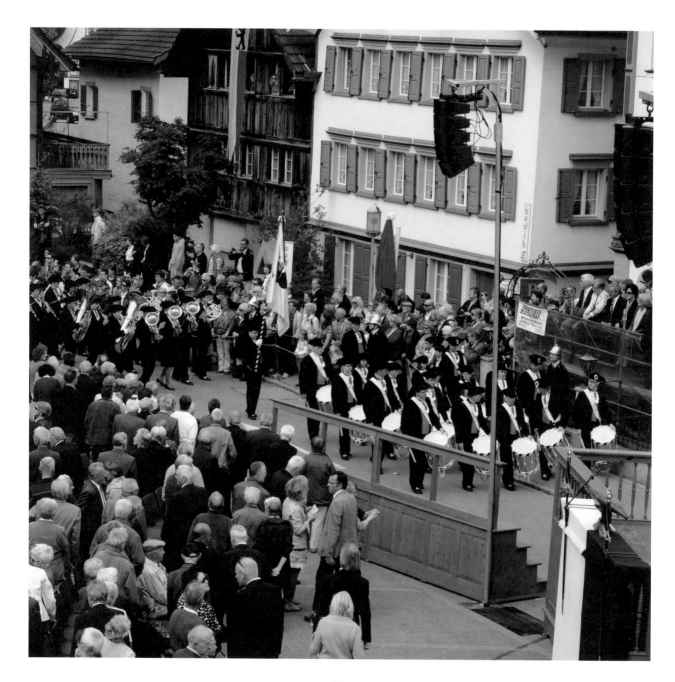

94

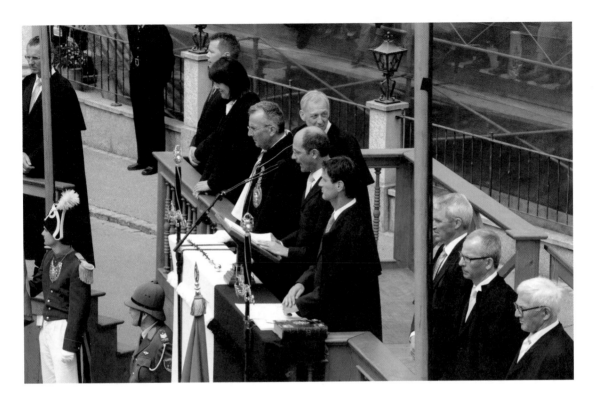

men wear a sword at their sides, a relic from earlier times. It was passed on from generation to generation and until 1991 it was considered the only badge of the right to vote.

Those who are able stand for the two hours the gathering lasts. Only some senior residents sit on wobbly chairs. Some empty brown beer cases to sit on are passed over the heads of the assembled.

The Landammann, the national bureaucrat, leads the Landsgemeinde. He conducts the elections and establishes the order of business. Then comes the point when the "s'Woot isch frei", the word is free, and the podium is open. Anyone may step up, climb onto the "chair" and express himself or herself, demand changes or seek election. And sometimes, because they are free to speak, the speaker veers off the topic of the debate, into a family dispute or an injustice in a land deal. The audience listens patiently; sometimes a murmur or a snicker ripples through the crowd. That's also part of a Landsgemeinde: an all-purpose release of tension.

Finally, regardless of how long the debate has lasted, the vote is taken. The colorful crowd becomes pink when everyone raises their hands. The Landammann estimates the majority by eye, which is also part of the tradition. An actual count is conducted when it is too close to call.

Then, after a couple of hours the serious business is finished, the civic responsibility has been discharged. Now the festivities of the big celebration can begin

[SH]

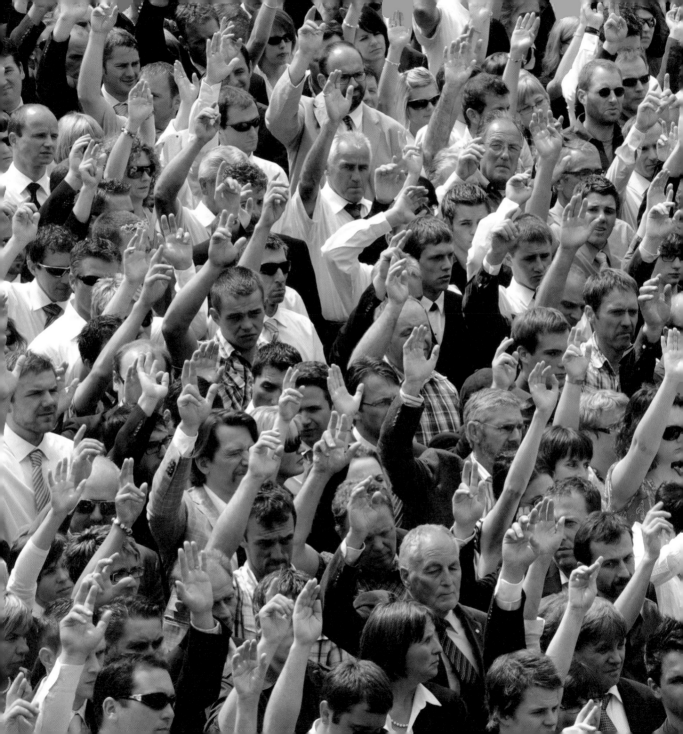

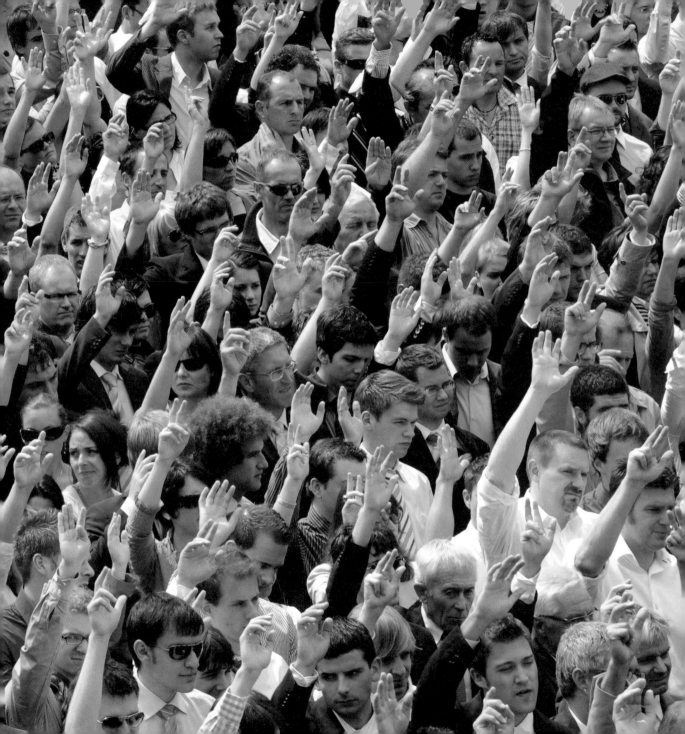

Lichter-schwemmen

On March 6

Ermensee in Seetal, canton of Lucerne

The dance of light begins after dusk,
around 6:00 p.m. It pays to come early
because the crowd is large.

The Lights in Children's Eyes

A small, unassuming creek in Ermensee in the Lucerne Seetal swells to a sea of light. Quiet, unspectacular, beautiful.

They sparkle and gleam. Dozens of lights float on the water, gliding through the darkness, observed by many pairs of eyes. No, we're not in Thailand at the Loi Krathong festival of Lights. We're in the canton of Lucerne. The sea of lights swims on the Aabach creek in Ermensee in Seetal. Real wax candles stand upright on little wooden boats with crosses, heathen arches or stair-like works of art. Children gingerly lay their little wooden barques on the water. With a little shove the light begins to swim.

They can't enjoy the view for long. The lights come quickly to an end, just a few meters downstream, past the amazed spectators, where the journey is finished. The little boats have reached their goal and are fished out from the village creek by fathers, mothers and grandparents. After a short trip back to the starting point, the procedure starts over again. The adults quickly tire but the children can go on for hours. "We do it as long as the candles burn", says one of the fathers, after he has marched up one side of the creek and crossed the little bridge to the other side to the start, seven times. These one-way paths are designed to prevent the children from inadvertently falling into the water. It doesn't always help. Torches illuminate the path, the bridges made of wood planks ease the climb.

No one knows exactly since when and why the children let the lights dance in Ermensee. Folklorists have looked back in the distant past. There were the farmers who offered sacrifices to the water gods out of fear in order to protect their farmland from flooding. They launched fire on the water and celebrated a heathen spring festival. Supposedly in the 5th or 6th century the Irish wandering monk Fridolin made a stop in Ermensee in the middle of the spring fire festival. Inspired by the desire to spread Christianity throughout the entire world, Fridolin mightily preached the new faith. According to legend he actually succeeded in reinventing the festival in honor of the water gods. From then on the lights on the Aabach celebrated the victory of Christendom over the water gods. Another, more pragmatic explanation was also provided in Ermensee: when the days became longer and the nights shorter in March, then less light was needed in the house and in the

barn. Therefore, the light was sent downstream in the true sense of the word.

One thing is certain: the grandfathers pass on their works of art made of wood to the next generation, whose members gladly accept them and continue the tradition, letting the lights dance in Ermensee. On the 6th of March there is a bit of a village festival mood in evidence. The music society plays, the yodelers exercise their art and the president of the commune gives a speech. The children are rewarded with a *Mutschli* (little bun) and a *Cervelat* sausage, while the adults can buy grilled meat. The gymnasts and the culture association take care of the physical well-being of the village. As is so often the case with customs the clubs keep alive the traditions and even maintain them beyond the boundaries of their own locality.

After body and soul have been strengthened, often shortly before the children go to bed, something happens in Seetal which appears nowhere in the old chronicles. Under the supervision of the adults the 5th and 6th graders launch small balls of burning straw in the Aabach. Looking like oversized fireflies these burning little balls swim downstream, overcoming every hindrance and since this time the little lights have no last stop, they float downstream in the direction of Lake Hallwil, burning out at some point. Where does this innovation come from? Who knows. In times of climate change it can't hurt to propitiate the water gods a bit.

[**KB**]

From a temporary wooden walkway, children and their helpers let the small works of art glide into the water.

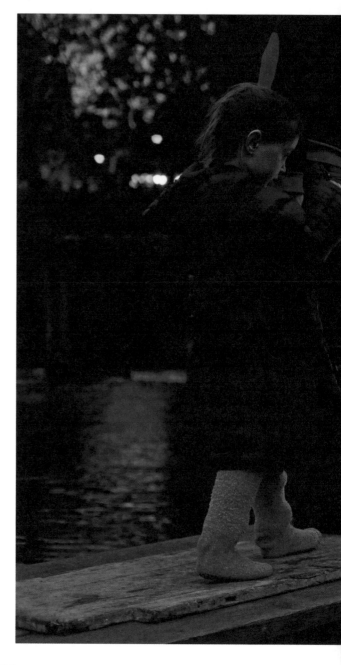

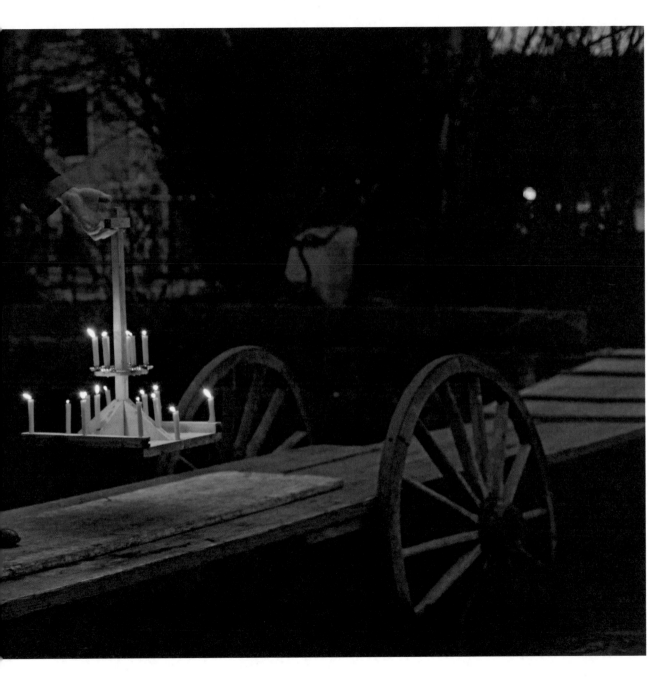

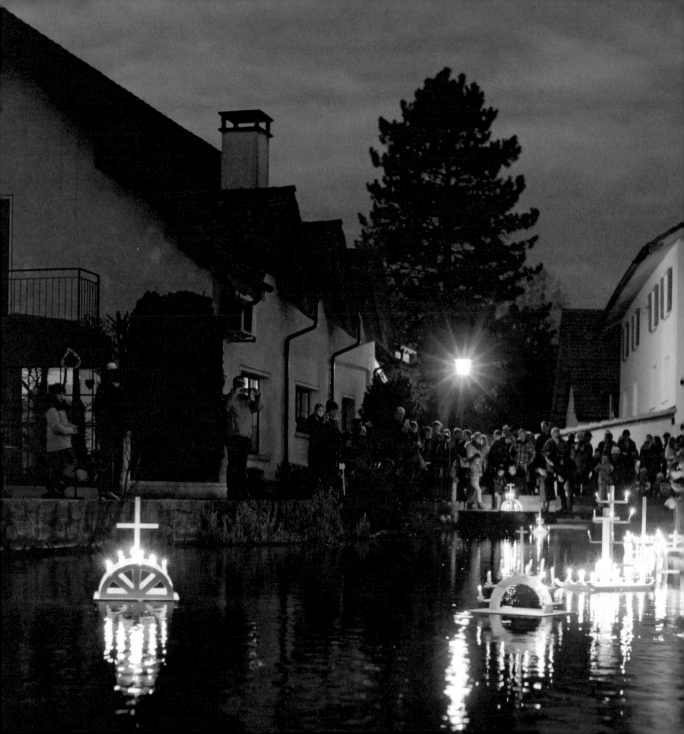

NO ONE KNOWS
EXACTLY SINCE
WHEN AND
WHY THE CHIL-
DREN LET THE
LIGHTS DANCE IN
ERMENSEE.

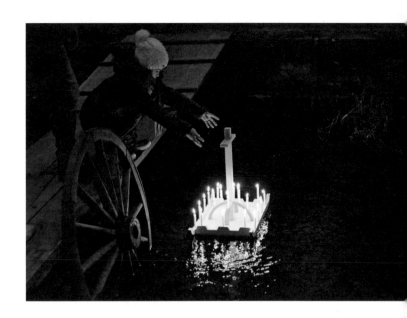

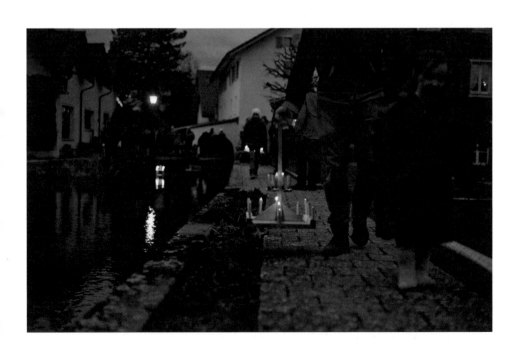

Rigi-Schwinget

The beginning of July, with a postponement
date at the end of July

Rigi Staffel. The route runs from Vitznau or Arth-Goldau,
where one boards the cog railway to the Rigi.

The advanced sales start at the beginning of April.
Buy tickets early, ideally as combined tickets including
the use of the mountain railways.

Brothers in Battle

They embrace each other like in a hug and brush off each other's backs at
the conclusion of each match: in spite of brute physical strength the Rigi Schwing and
Älplerfest festival shows that Schwingen is a thoroughly friendly encounter.

Two men stand in a sawdust ring, slowly gathering their strength. A quiet settles over the bleachers where the spectators sit in the summer heat, drink beer, eat sausage and sometimes snuff tobacco from the backs of their hands. The favorites of this year's Rigi Schwing and Älplerfest festival are standing in one of three rings, who coincidentally face off in the first of six rounds. Suddenly, sawdust can be seen on one of the shoe soles twisting in the air as one of the *Schwingers*, literally people who perform the act of swinging, presses the other over his bent knee – now they're both lying on top of each other. The one on the bottom struggles, arching his back and rearing up.

One seldom sees men come so close to each other. They stand in the ring, almost embracing each other, grab the rear end of their opponent until they have a grip on the Schwinger pants. The way they start to rock back and forth in this posture, from one leg to the other, staggering in a neat circle, you would think they were dancing to the folk music played by the musicians on a small wooden stage next to the sawdust ring.

"They're testing each other's balance", explains Weber Manuel, a young expert and himself a Schwinger. Putting the surname in front of the first name is part of the tradition of *Schwingen*, or swinging. He explains that the combatants use the rocking movements to find the weak spots of their opponents, and how much momentum and strength they need to press the shoulder blades of their opponents in the sawdust and to win.

The first representation of Schwingen goes back to the 13th century. In the Swiss Alpine festivals of the time the prize for winning a match was a piece of trousers cloth, a sheep or some other reward in kind. This national sport called *Hoselupf* first appeared in the Alphirtenfest, or Alpine Herdsman's Festival in 1805. When Switzerland was occupied by the French, the brutal matches were staged in order to boost the national morale. And maybe, at least among themselves, to show how strong they were.

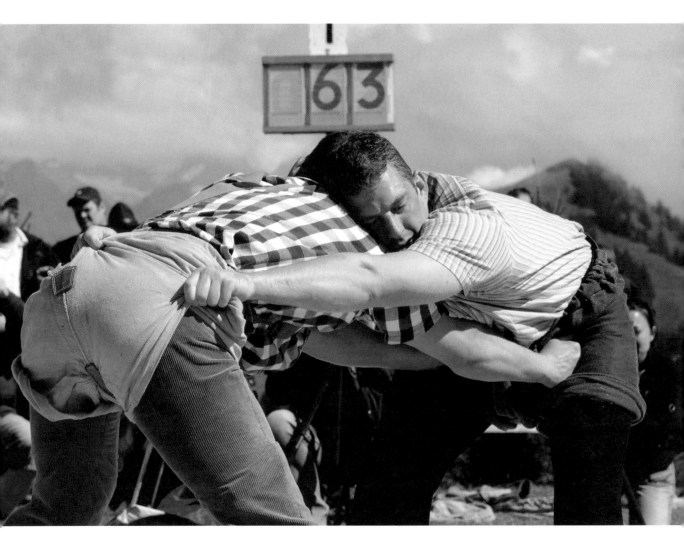

Schwingen has retained a certain simplicity dating back to its origins. Schwingers are still amateur athletes. In addition to building up their strength with targeted fitness training, they draw on their work as butchers, cheesemakers or carpenters. The events are becoming ever more professional, larger and above all more popular.

The tickets for the Rigi-Schwinget, as are those for the many other Schwing festivals held during the summer throughout Switzerland, are very often sold out in advance.

The Swiss TV cameras and a local station are standing on the Rigi around the three rings. Many journalists are here for the event and there are

5,000 spectators in the bleachers. They're not just looking at the rings, they're looking at the distant green Rigi mountain landscape and beyond that the white peaks of the Alps. Young men in snug fitting T-shirts and beards are sitting there, women with cut-off jeans, white haired older women and old men with crooked cheroots in their mouths.

Maybe the role of Schwingen from earlier times, when the country was occupied, has continued until today: the sport boosts morale and brings the most diverse people together. This kind of amicable behavior is also reflected in the ring. In spite of the physical aggression the sport is characterized by a display of decent, almost tender politeness. In the first rounds, when one must not contend for the top positions, the victor barely rejoices. And he always gives his opponent a hand to get up, brushing the sawdust off his back.
[SH]

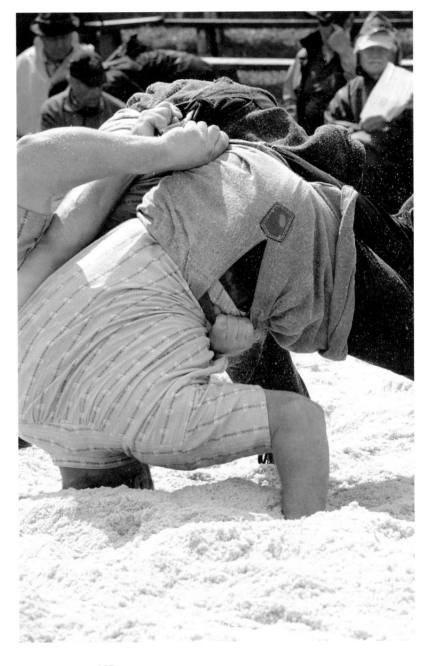

Suddenly, sawdust can be seen on one of the shoe soles twisting in the air as one of the Schwingers presses the other over his bent knee.

Perhaps the function of Schwingen from the time when Switzerland was under foreign rule is still valid today: sport strengthens national pride and brings the most diverse people together.

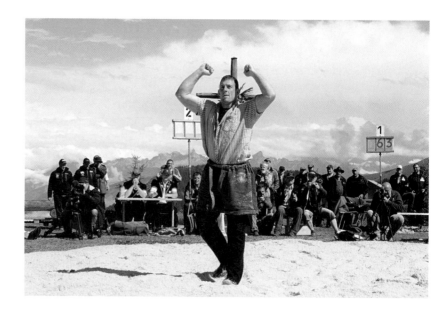

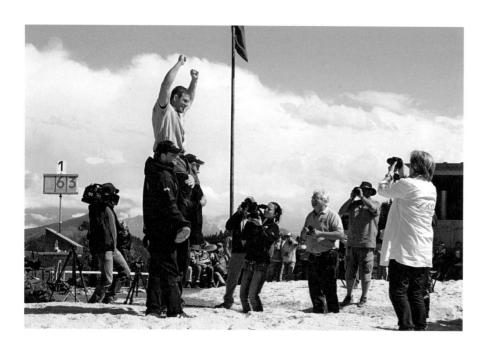

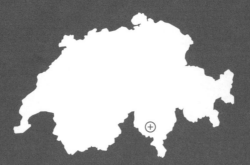

Sagra del Pesce

On the second Sunday in March, if it rains,
on one of the following Sundays.

In Locarno-Muralto directly on the lake

Those who want to witness the mystical
beginnings must get up early. At precisely 6:30 a.m.
the fishermen embark on the lake.

A Pike is King this Sunday

The fishermen's festival: mystical and silent,
loud and hearty. Fish are the common denominator on the
Sagra del Pesce. The festival ushers in the spring.

Silence reigns over the lake. Muralto, the town on the Lago Maggiore, near to Locarno, is still sleeping. Three giggling revelers creep silently home, crossing the path of an early morning jogger. Seagulls scream, other birds are beginning to chirp. Human voices can be heard. A group of men are talking on the shore next to pot-belly stoves, which probably used to be copper vessels for boiling laundry. It looks like today is not a normal day. Cut wood has been piled. Somewhat concealed behind this ensemble three fishermen are preparing their boats. Without ado, just routine. Every movement correct. Their goal is a most plenteous catch. They're looking for large, heavy fish today, at the festival of fishermen with the mellifluous name Sagra del Pesce. At noon at the long rows of tables hundreds of people will enjoy the fish, polenta and Gorgonzola, laugh, look out on the lake and listen to live music.

But there are no traces of that now. At 6:30 a.m. sharp the boats set out on the lake. At the same time other boats shove off from the opposite shores of Brissago and Mogadino. There are a total of 30 boats, with different fishing gear organized in three categories. The fishermen, who are looking for trout, pike, zander and whitefish, bring back the catch around noon and it's auctioned off on the spot. However, the proceeds won't go to the fishermen. They go back in the lake, or to be precise in the till of the Sant' Andrea Fishermen's Association. The association has been administrating the fish stock in the lake year after year since 1952 for this festival in March. Not without pride the president of the fishermen's association, Ivan Pedrazzi, points to the passionate participation of the fishermen, almost all men. In January, for example, they sink decommissioned Christmas trees in the lake. At a depth of five to eight meters divers connect up to 1,000 skinny fir trees, creating a kilometer long hatchery. For the fish the fir tree hatchery is a blessing. For the fishermen who don't know their way around it's a nuisance, because their hooks get caught in it.

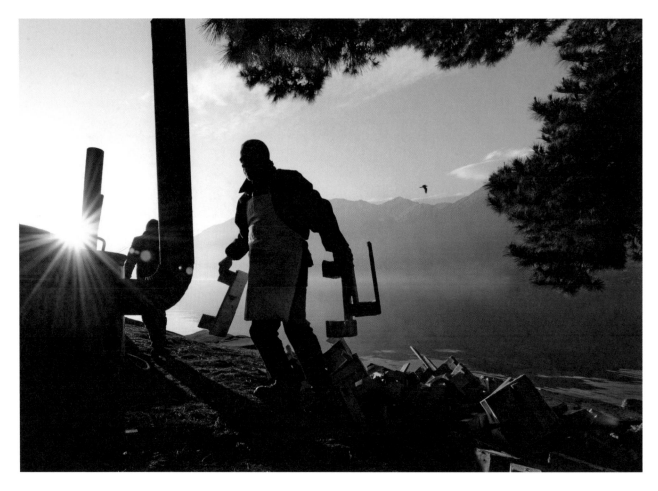

Meanwhile the Muralto shore promenade has come to life. Tables are filling up. Men in discussion have donned white aprons. The ovens are lit. It smells like fish. 200 kilograms of Merluzzo (cod) from the North Sea is layered in metal casseroles, covered with cream and spices and shoved into the hot wood stoves. And the small silvery fish called Alborelle, sizzling alongside in hot oil, are also imported. In former times, as the fishermen like to say, they swam in giant shoals in the

Lago Maggiore. Nowadays, they are rare. The few left behind are protected.

Right next to the chefs the aspiring fishermen have thrown their bait in the sequestered part of the harbor. Those under 14 may participate and the chances for success have been increased because this morning dozens of farmed fish have been dumped into the water. Without them there would hardly be anything to catch. In the somewhat cooler temperatures in March there are hardly any

fish close to the shore. They're out swimming deep in the lake, while the patient fishermen are waiting for them in their boats.

Barely noticed by the chattering crowd the fishermen return to the harbor late in the morning. They watch with pride as their catch slips into the big basin slip that is set up especially for this purpose. As if on stage the swimming performers are duly admired. Whoever correctly estimates the weight of the largest fish in the pool wins that fish. Everyone can participate. Discussions, estimates and wagers abound. The object of attention is a particularly fat pike. How much could it weigh? A few hours later Ivan Pedrazzi announces the solution to the quiz: the magnificent specimen weighs 9.9 kilograms – the makings of an impressive fish dinner. But the pike is rescued from his regrettable good fortune by the winner: she sets the fish free so that it can continue swimming and reproducing in Lago Maggiore.

[KB]

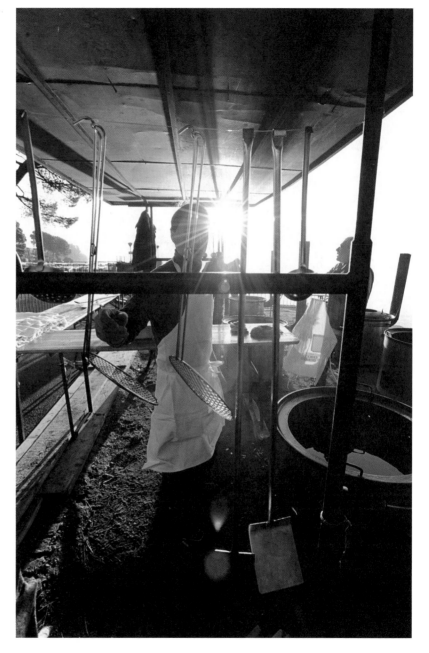

Fishermen can cook as well. At sunrise they heat the stoves.

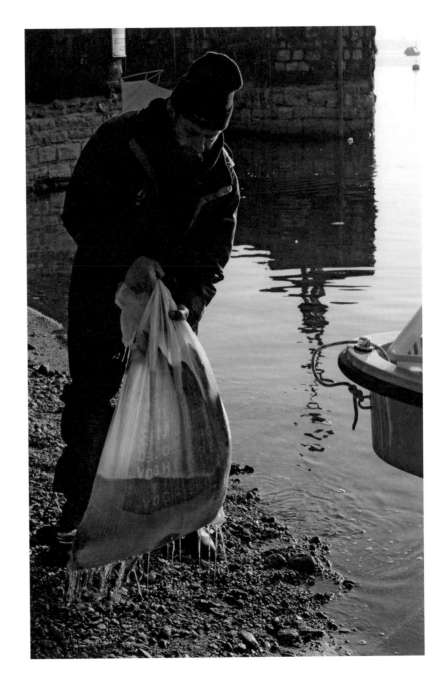

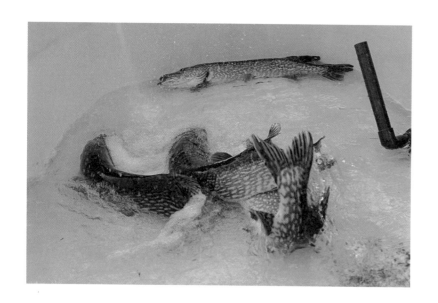

WHOEVER
CORRECTLY
ESTIMATES THE
WEIGHT OF
THE LARGEST
FISH CAN TAKE
IT HOME.

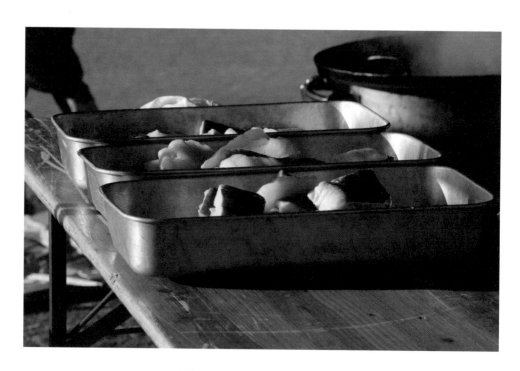

Flinging Disks

In Dardin and Danis-Tavanasa on the first Saturday of Lent.
In Untervaz on Septuagesima Sunday.

In the villages of Dardin, Untervaz and Danis-Tavanasa

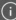

Because of the noise in the festival tent in Dardin, one can
hardly hear the calls of the disk-flinging men and boys. The acoustics
are much better a few streets into the village.

Fire Sails Through the Air

**The first inhabitants of the valley wanted to
banish winter with the glowing disks flung out in the night.
To this day the significance of this custom has evolved.**

Olivia. Or was it Livia? The name echoes from the mountain into the darkness. It is a voice that slightly cracks because it has to scream so loud that you can hear it down in the valley. Along with the scream a point of light shoots into the night, a burning disk as large as a coffee saucer.

On this first Saturday of Lent, boys and single men, who are surrounded by large campfires, fling disks with rods in the air from a hill near the village of Brigels in the canton of Grisons. The custom is called *Trer Schibettas* where the majority of the population speaks Rhaeto-Romanic. It's called *Schiibaschlaha* in Untervaz.

Flinging glowing disks of wood into the valley is an old ritual whose background has shifted over time. Hundreds of years ago the first inhabitants of the valley wanted to banish winter with the burning disks. Over time the motivation behind the flinging has changed from one of banishment to attraction. Today, along with the glowing disk a dedication to a woman is flung out into the night: "Tgei biala schibetta per la..." or:

"What a beautiful disk for the ..." Olivia, for instance. However, only when the shot is a good one. If it misses, it becomes a *tgagiarar*. Instead of an object of devotion the men dedicate the errant missile to a less beloved teacher, politician or football club.

Down in the village, where a festival tent has been set up between Volg and the church, the unmistakable aroma of a Swiss village festival is in the air: moist earth, the white tarpaulins of the tent, the roasting sausages and coffee schnapps. With a touch of freshly cut wood. More disks are cut in a dugout for the children to take home. The villagers have arrived, joined by a few guest from out of town. The specators lean back, peering into the darkness and try to make out the glowing disks flung down into the valley.

Single men and boys from the third grade and older have been churning them out since the beginning of the year. A piece of wood is cut in disks with a hole drilled in the middle so that it can be mounted on a stick. It looks like an umbrella for a midget. The disk is first shaped with

an axe, then brought into form with a knife. They are circularly cut and strung on a cord. The boys sling them over their shoulders like wreaths and ascend the hill in the darkness after the prayer service for the youth on the first Saturday of Lent. The wooden ramps are waiting in readiness. The *Schibetta* is stuck on a rod, held in the fire until it is glowing, swung in the air a few times and flung from the ramp into the valley.

Is that how the love relationships and marriages start in the valley? A boy on his way up the hill offers a more realistic assessment: "You can't say that today. We just make sure to call out once the name of every single woman in the village." In former time the boys visited the object of their admiration whose names they had called out in the night. Meanwhile, as the men were cutting the disks, the girls were stirring the batter for the carnival fried dough or *Patlaunas*, which they served to them later.

Today, after the disks have been flung, everyone meets in the festival tents for flat cakes and sausage. According to Micha Volken, the president of the youth brigade and the organizer of the festival, the disk flinging custom has taken on another meaning. The population of the little village has shrunk and the young people are moving away. But: "Although almost none of the young men still live in Dardin, they still meet. They fling the disks to banish the winter and to declare their loves. And lately to celebrate solidarity."
[SH]

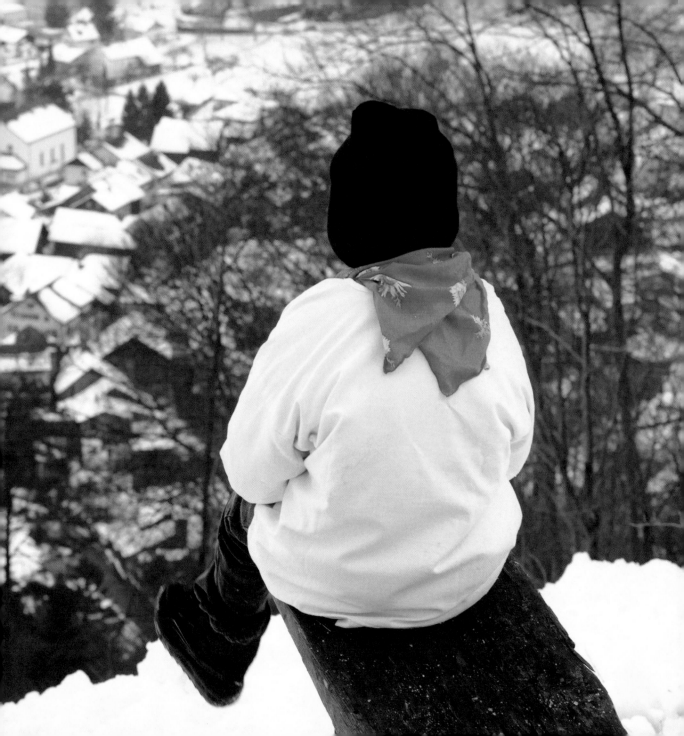

WITH PIECES OF
WOOD REMINISCENT
OF SHINING SUNS THE
FIRST INHABITANTS
OF THE VALLEY
WANTED TO DRIVE
AWAY THE WINTER.

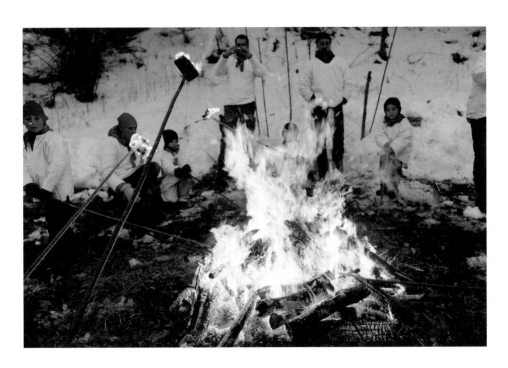

Along with the scream a
point of light shoots into the
night, a burning disk as large
as a coffee saucer.

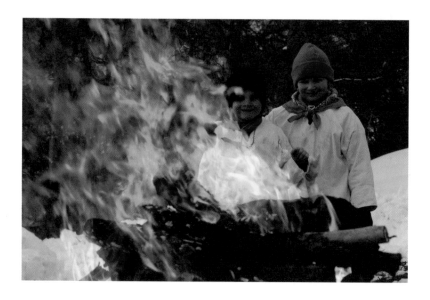

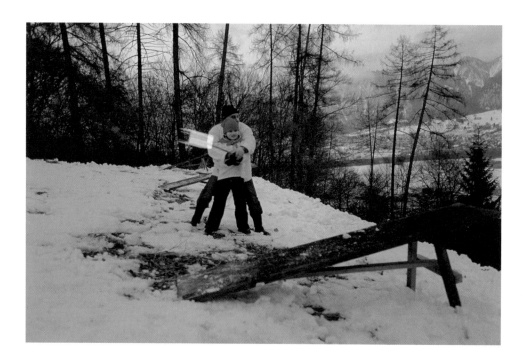

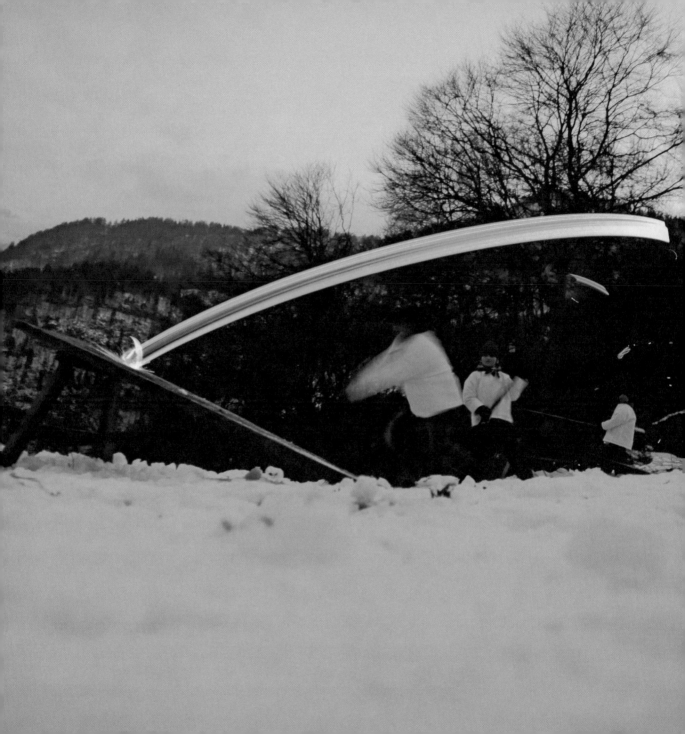

Schlitteda

At the end of January and beginning of February

The villages of Pontresina, Champfèr, St. Moritz and Samedan organize Schlittedas,
which today are only held partly in one village or which also extend
to the neighboring village. For instance, the St. Moritz group travels to Silvaplana, and
the Pontresiner extend their celebration from their own village to Val Roseg.

In order not to miss the sleighs, it is recommended to inform oneself
about the route of the respective groups beforehand.
The best way to do that is to ask the relevant municipal administration,
the village youth group or the costume clubs.

Sliding
Into Happiness

The Schlitteda Engiadinaisa was perhaps the first dating platform in the Upper Engadine. It became a welcome romantic highpoint in the long winters.

The first thing one hears is a rustling of little bells on the leather harness on the necks of the horses. Then the clattering of hooves on the street covered with just a thin layer of snow. The traditional red costumes stand out against the white snow, as do the colored sleighs with the beautifully attired women, chastely sitting sideways. The men in tuxedos and stove pipe hats walk alongside the horses, but can also take up position on the back of the sleighs. That's how the Schlitteda moves thorugh the snow-covered Upper Engadine on this Saturday.

Sleighs like these have been traveling through the bitterly cold, snow-covered expanses of the Upper Engadine for 200 years. They were the first dating platforms in the area. The Schlitteda Engiadinaisa was a very local dating service, but much more exciting than the digital profiles on the Internet: the village youth, called *Giuventüna* here, were grooming themselves on this Sunday at the end of January, beginning of February, longing for company and some fun after all those dreary winter days. They wore their finest clothes, and those who had one, put on a traditional Engadine festival costume. Because it was so warm, the women used the red cloth from the uniforms of the mercenaries who had served in the French army. An indication of how central the Schlitteda was for the people in Upper Engadin can be seen from the clause in the farm leases reserving a horse free of charge for the festive sleigh ride.

As a rule, a lottery determined which cavalier was to travel with which lady in the artfully decorated festival sleigh to the next village over the frozen lake in the Upper Engadine through the thick cover of snow in the larch forests. There one met the other young people, there was dancing at balls, eating and drinking. And the cavalier and his lady often went home in their sleighs with overflowing hearts.

At the end of the 1940s, Hans Mohler, one of the storytellers of Grisons, had this to say about these events: "As the evening progressed, filled with inviting music, singing in rounds and the clinking of glasses, well past midnight, for some it became the occasion of a New Year's dream. And

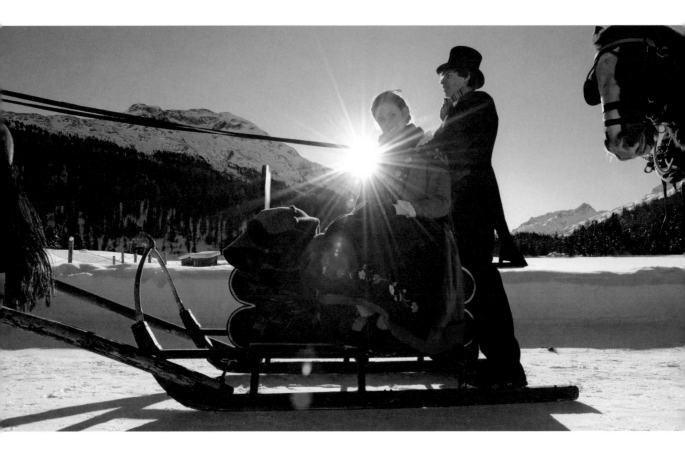

when Easter came around and the engagement was announced, the older villagers grinned, they knew it all along, it was the Schlitteda!"

Today, the carriage horses are harnessed to the Schlitteda sleighs, which for the rest of the winter pull the tourists through the enchanted landscape around Sils Maria, St. Moritz, Pontresina and Bever. The passengers in the sleighs are mostly married couples or members and friends from the costume club.

Like Gian Clalüna, member of the St. Moritz costume group, whose wife doesn't participate in the Schlitteda. He says: "I like the Schlitteda fes-

tivity." Even if today it no longer fulfils the original function of searching for a partner, he can still feel the excitement this earlier occasion must have conveyed. The joy of dressing up in one's finest clothes, decorating the horses and bringing them out to the richly decorated sleighs. And the feverish expectation of perhaps meeting the love of your life in the neighboring village. The emotions today are a bit more restrained: Gian Clalüna looks forward to the sociability of his costume club, the midday meal with good wine and local Röteli liqueur.

[SH]

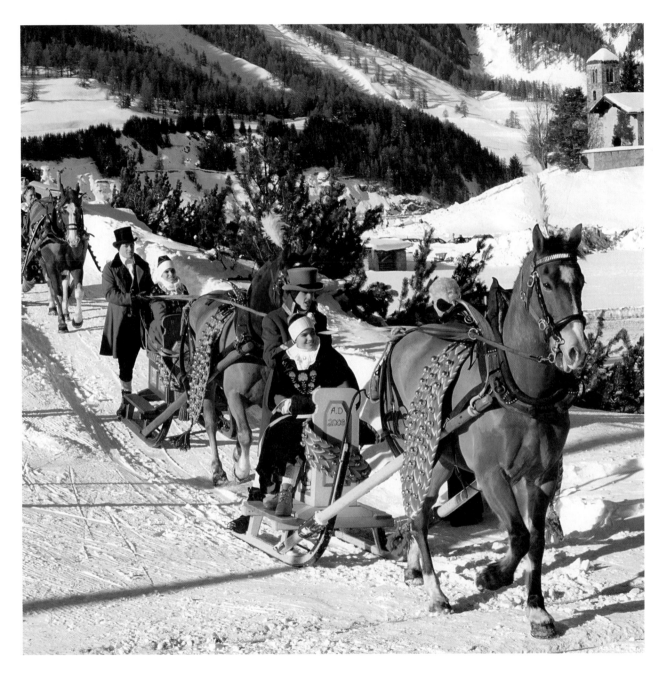

Livestock Show

From the end of September to mid-October. The exact dates for all the livestock shows
in the Ausserrhoden towns can be found on the Appenzellerland website.

In the various municipalities of the Appenzell region

Bring along good shoes to take a hike to one of the hills with a view of
the valley, joined by the clinking of the cowbells along the way.
One of the many routes is the Hundwiler Höhe mountain (1,305 meters above sea level).
A hiking map can be issued at the Appenzell Volkskunde-Museum.

Try *Siedwurst*, a light-colored sausage eaten raw or cooked, together with some Appenzell
Chäshörnli (cheese macaroni) or meat loaf with mashed potatoes.

Who's the Fairest in the Appenzellerland?

In the livestock shows in fall it's all about the prizes for the most beautiful and productive cows. But their owners with their brightly colored costumes and the traditions surrounding the livestock show alone are worth the trip to the hilly Appenzell region.

You can't miss the road to the livestock show in Stein in Appenzell Ausserrhoden. It doesn't matter which direction you come from, just follow the carpet of cow flaps the cows have left behind on their way to the arena. The farmers and breeders come down the hills from all the farms around Stein early in the morning with their most beautiful cows. They drive their elaborately dolled up animals past the spectators through the village and under a wooden archway decorated with flowers and sayings onto the grounds. "Sönd willkomm!", it says on the archway, or "A warm welcome". That's not just for the cows. The livestock show is the meeting point for the farmers, local citizens and lately for more and more tourists who travel here especially for the festival.

Before the *Stellen*, or the categorization of the cows, can begin, they make a last stop in the beauty parlor. Young boys wearing *Öbergwändli*, a type of smock, scrub them down one more time and backcomb their tails into bovine form. The people milling about here on the festival arena on this clear September day look good, too. Some of the women are wearing the Ausserrhoden weekday costume and have braided their hair in elaborate coiffures. Men in the colorful herdsmen festival costume, a red tucker, yellow lederhosen or brown woolen pants, studded suspenders, a black hat with a wide brim and a *Schuefe*, a gold earring in the shape of a cheese skimmer, are standing around smoking cheroots. A group of men has assembled off to the side, right in front of the large bells, which have been taken from the cows after making their way through the village where they are now being proudly presented. Barely audible between the mooing of the cows and above the tangle of voices of the festival visitors the men have started to sing. *Zäuerli* is what one calls this natural yodeling in Appenzell Ausserrhoden. It is somehow deeply moving. Several times in the course of the day one can hear a *Zäuerli*. But no sooner than one has tracked it down it's already stopped.

In the midst of this interesting supporting cast the leading actors may not be forgotten: the cows. Divided in categories according to age or productivity, they are now standing by, waiting for evaluation. In deep concentration the judges circle the cows with clipboard and pencil, stroking the

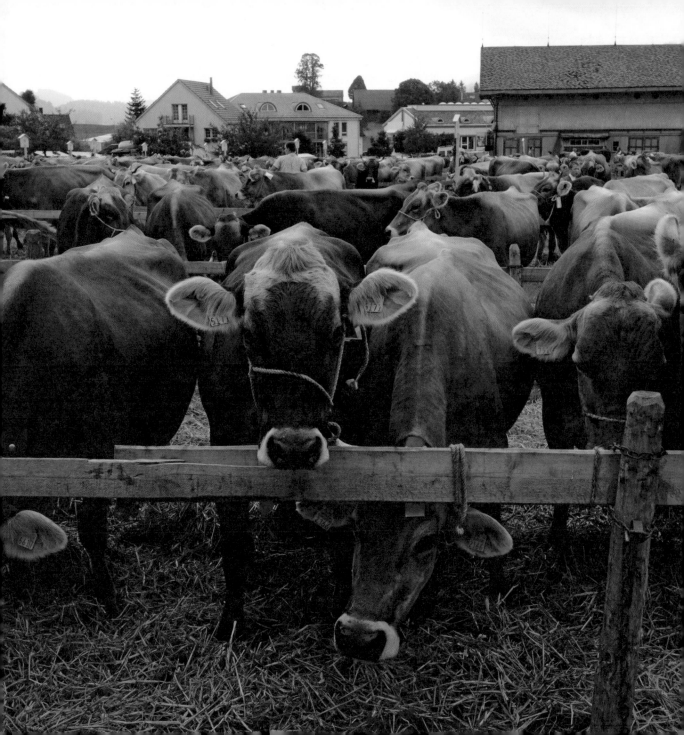

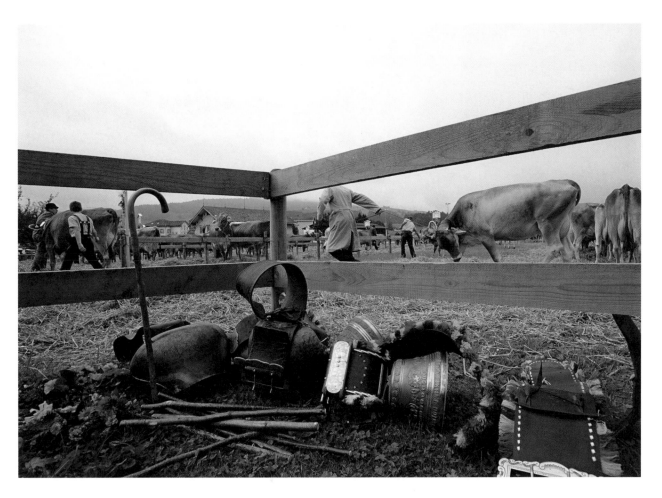

contestants' back, patting their ribs and bending over to inspect the udders. Cow comparison is not so simple because the differences among the breeding animals are not large. The cows with big, full udders, straight backs and well-formed ribs get the highest scores. The experts rely solely on their unaided trained eyes. No tape measures are needed, that's a matter of honor. The cows are completely oblivious to the hubbub around the beauty contest. After being evaluated one

of the winners contentedly deposits a cow flap, continues chewing her cud and finally lies down disinterestedly in the straw.

The highpoint of the livestock show is the presentation of the Miss Stein award for the most beautiful cow in the arena. Although she doesn't get a home story like a real Miss, at the end of the day she may wear the richly ornamented winner's bell in her stall.

[SG]

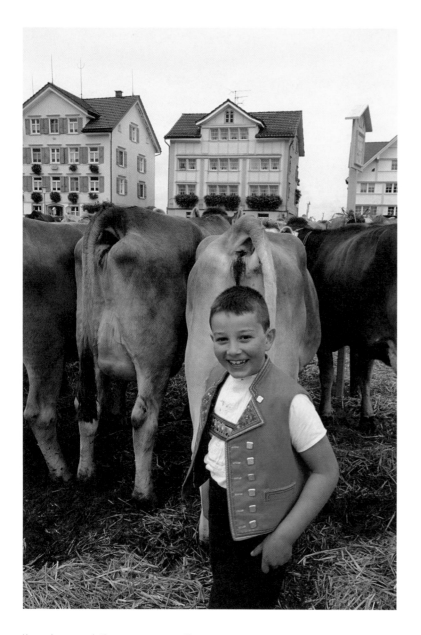

Young boys scrub the cows one more time
and backcomb their tails into bovine form.

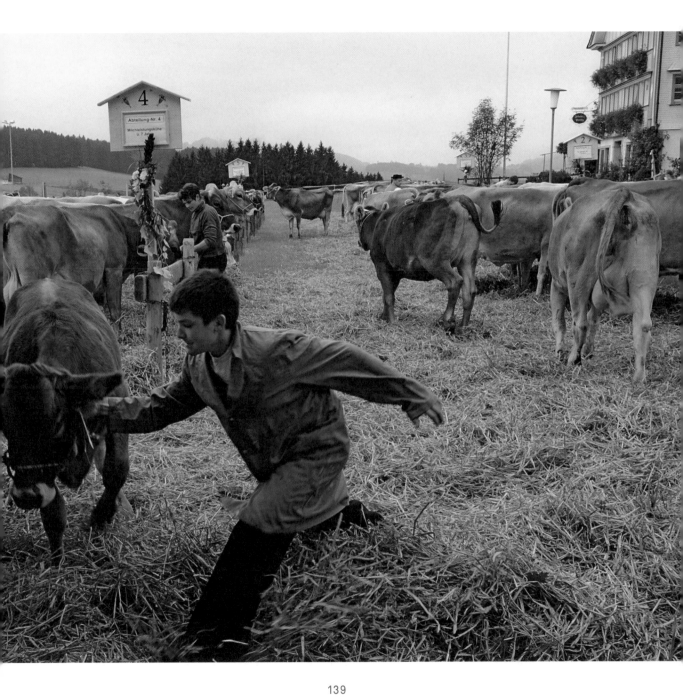

Tschäggätta

Between Maria Candlemas on February 2 and
Ash Wednesday (except on Sunday)

In the entire Lötschental valley. On Fat Thursday the *Tschäggättälöif*
starts in Blatten and goes to Ferden.

Try *warme Wy*, or mulled wine and *Chiächlini*, a small fried cake
made of sweet dough, only available during carnival.

Fascinatingly Weird

Every year in February a narrow, quiet valley the canton of Wallis is transformed into a village of fools. Strange creatures come to life, beings from another world.

They're not friendly, these figures. They suddenly emerge from the cover of darkness, half giant, half animal, only illuminated by the soft light cast by the streetlights. Large, hairy and loud, they stumble through the narrow alleyways of Blatten, a small village tucked away in the Lötschental in Upper Valais. These are the Tschäggättä. Here and there the looming hulks stand still, making weird noises, wrenching their arms. They rear up in front of warmly clothed spectators, whispering to them incoherently, embrace them or awkwardly cuddle up to them. Sometimes especially young women land in the snow and are rubbed with it.

It's carnival time. In the Catholic villages local order is turned upside down. It always begins in Lötschental the day after Candlemas, a Catholic holiday on February 2 lasting until Ash Wednesday. Dressed up creatures are in charge. In the evening dozens of men, and in the last few years, also women, slip into a different skin. It's actually more a squeezing than a slipping because those who select such costumes submit themselves to an ordeal to put them on. There are several layers beneath the thick pelt from sheep or goats: functional wear, articles of clothing worn inside out including pants and jackets. *Triämhändschen*, or thick wool gloves protect against the biting cold. Shoulders are widened and beefed up with straw-filled cloth sacks that were formerly used as padding for carrying wood. Crowning off the whole costume is a heavy wooden mask mostly hand-carved from Arven pine. They're lovingly made by hand by one of the approximately 30 wood carvers in the valley. One of them is Bruno Ritler. The Blatten municipal employee has carved many such masks, invested hundreds of hours, running into weeks and months in his work. Like all wood carvers, he has his own style. There are no restrictions. Modern, traditional, futuristic – everything that pleases. Most carvers don't just work on the masks; they put them on at night, too, while wandering about in the darkness, sometimes quietly and sometimes making loud noise with bells or cowbells. They take a break in restaurants and bars, without saying a word. To avoid being recognized, to be free and, of course, to continue a long tradition, all contributes to the charm, according to Bruno Ritler.

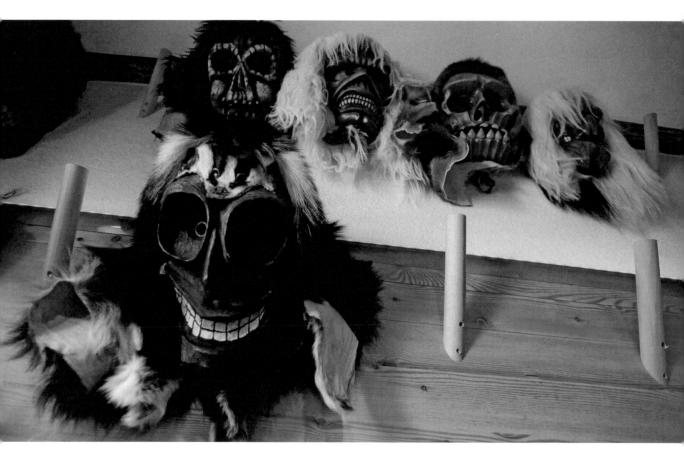

The people in Lötschental have been dressing in disguise for hundreds of years. Many historians believe that the custom developed from Baroque church theater in which the devil as the tempter played a role. Others refer to the legend of the masked *Schurtendiebe*, or natives who hundreds of years ago were driven into exile by the Alemanni and forced to settle on the shadow side of the Lötschental. They were poor and hungry and supposedly crept out at night to steal, disguised in animal hides and wearing wooden masks. In the Middle Ages this story merged with the Catholic customs of carnival and Ash Wednesday. The correct version has not yet been determined.

However, one thing is sure: in the 1980s the custom was on the verge of dying out. The nocturnal rampages had become a nuisance for the politicians. The *Betenläuten*, the ringing in the evening prayer at 6:00 p.m. had previously marked the end of the day. Now the men increasingly began to disguise themselves in the evening after work. They stayed out longer than the authorities liked and there were occasionally disputes. A general

ban was intended to prohibit the custom, which didn't sit well with the supporters. They didn't want to go down in history as drunkards or rambos. Therefore, they organized a demonstration, a so-called *Ahnenlauf*, or literally a march of ancestors. The impressive procession worked: the politicians gave in, *Tschäggättälöif* was born and since then has been an integral part of Fat Thursday in Lötschental. The procession draws more and more spectators every year. If you're counting on an isolated, chance encounter you will need some luck. The Tschäggättä are on the move throughout the valley during the entire carnival time and although they are currently in the spotlight one never knows where they will turn up. They have no schedule, coming and going as the spirit moves them. If they do by chance show up, the encounter with the gruesome figures will certainly be branded in your memory. [KB]

They suddenly emerge from the cover of the darkness, half giant, half animal.

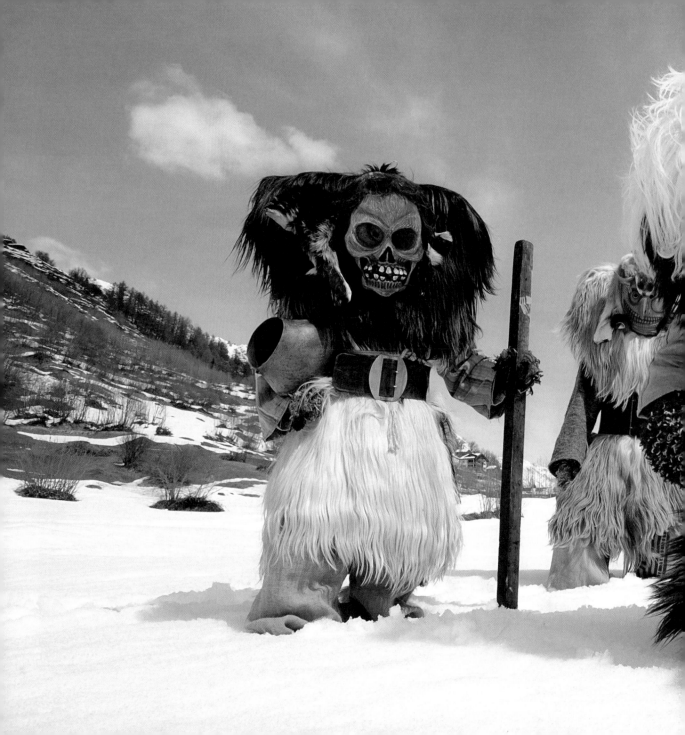

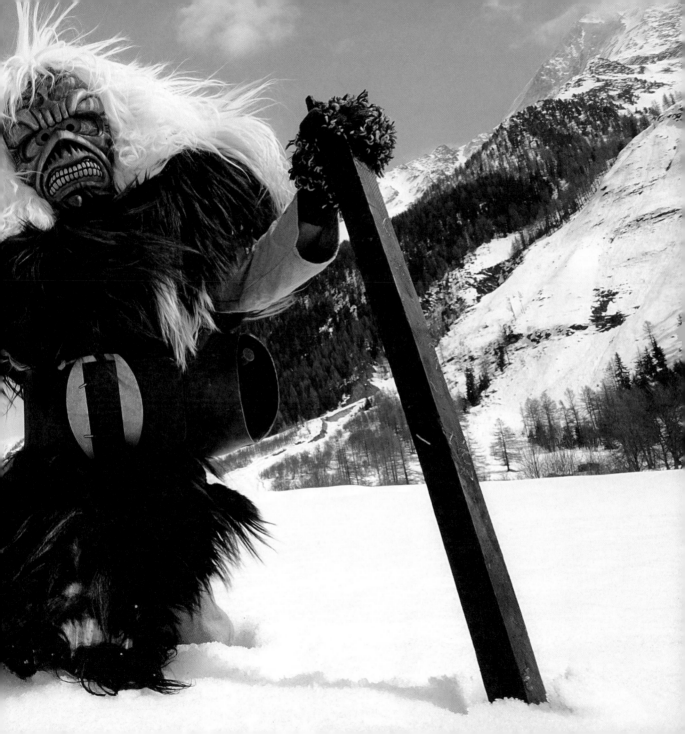

Alpaufzug/ Alpabzug

The grass determines when the cattle are herded up and down the Schwägalp. When the grass is high enough, the cows move up the Schwägalp, around nine weeks later they return.

Schwägalp above Urnäsch

The Urnäsch dairies feature the tangy Alpine Schwägalp cheese. Don't forget the sunscreen lotion.

Magnificent Cows, Proud Herdsmen

In the early summer in the Appenzell region many farmers
and their cows move up the Schwägalp beneath the Säntis. In August
they return to the valley. It's a snapshot from the past.

Early in the morning the mood is one of festive anticipation on the Schwägalp. The spicy, fresh air is still cool, with a whiff of the tell-tale cow barn. Five men stand closely together. A triad of three cowbells can be heard. The men tune up with a *Zäuerli*. One man starts in with a melody, a second comes in a pitch lower, and the others chime in. There is a touch of melancholy to the performance. It marks the day of homecoming for the livestock. Nine weeks ago dozens of cows and goats marched onto the rich green alp. Now the Alpine herbage has been grazed, it's time to go home.

Around 120 cows and two dozen goats have to return to the valley today. Every farmer brings his herd home in an orderly fashion, backed up by the whole family and friends of the dairy farmers. They drove to the Schwägalp by car early in the morning. Actually, the helpers are not dairy farmers. In daily life they work as craftsmen, chauffeurs, beverage dealers or butchers. But today they don the red-and-white *Sennechutten* in order

to help "their" farmers. First off, they get a hearty breakfast. *Fenz* is served, a filling porridge of butter, flour and milk. If cream is used instead of milk the dish is called *Rohmzonne*. There's also beef and pork loaf, bread and beer if one wants.

Freshly strengthened the men stand again very close to each other and take another *Zäuerli*. With reverence. With satisfaction. Conscious of maintaining an old tradition. Now the farmer can open the barn door. A loud mooing commences, the cows are restless, recognizing that today will be different than normal. The first cow stumbles out, eyes wide open. A second stubbornly digs in her hooves, showing no intention of taking the unfamiliar path to the valley. With a little persuasion in the form of a wooden prod she finds her way along with the rest of the herd downhill at a brisk pace. The sequence has been rehearsed. If a farmer has goats, they lead the way, escorted by a young goatherd in bright yellow lederhosen. His entourage includes several little female goatherds in traditional little skirts. All those who

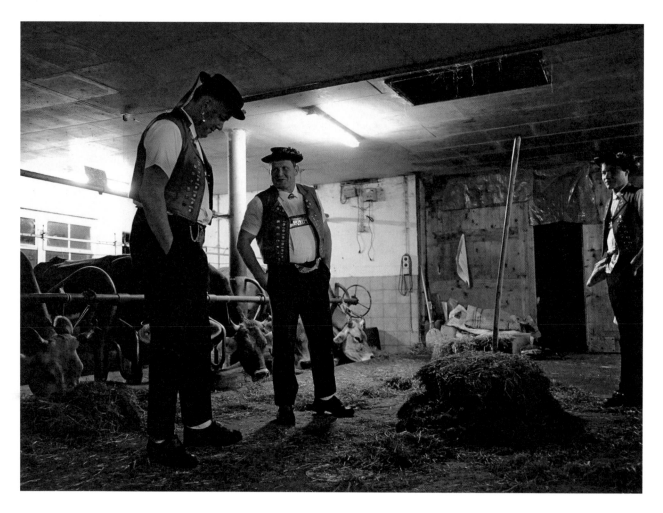

can keep up on the long trek can come along and the youngest today is just six years old. After the goatherds come the cattle herdsmen, the cows and finally the farmers. Individual cows jockey for position. Along the way the strongest has to prove that she is the boss. Intermittently, a *Zäuerli* rings out from the throats of the herdsmen. The world is an idyllic postcard. Those present are here with the conviction and certain knowledge

of the many who have gone before them. Historic documents show that more than 1,000 years ago farmers drove their cattle up the Schwägalp to spend the summer.

About a fourth of the way down eager spectators line the streets. Armed with cameras and smartphones, they shoot the nostalgic scene like paparazzi. The faces of some spectators quietly grimace with displeasure at the automobile traffic

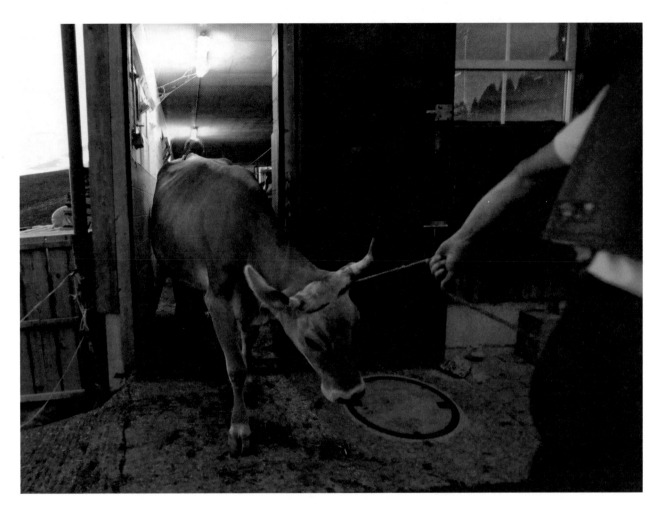

incongruously driving by on the non-restricted streets. Residents distribute cold drinks to the herdsmen; wine, beer, *Citro* and water are handed out with the call for good luck: "Wünsch Glück." The Alpine herdsmen are grateful for the refreshments. The cows and the goats drink greedily from the isolated springs along the way.

Finally, after a march of four hours through the Appenzell countryside, the longed-for goal is in sight. Astonishingly enough the remaining few meters seem to last an eternity. With their last ounce of strength the cows struggle back to their familiar meadow. Finally. The herdsmen intone an ultimate triumphant *Zäuerli*. And the cows, in a burst of energy, greedily munch on the rich green grass. They stay here in the valley until next June when repeating the whole ceremony in reverse. **[KB]**

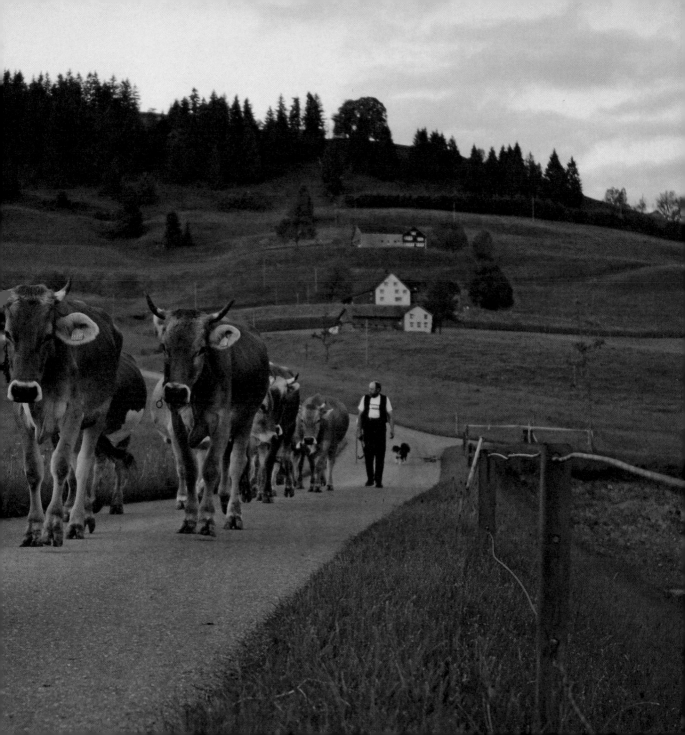

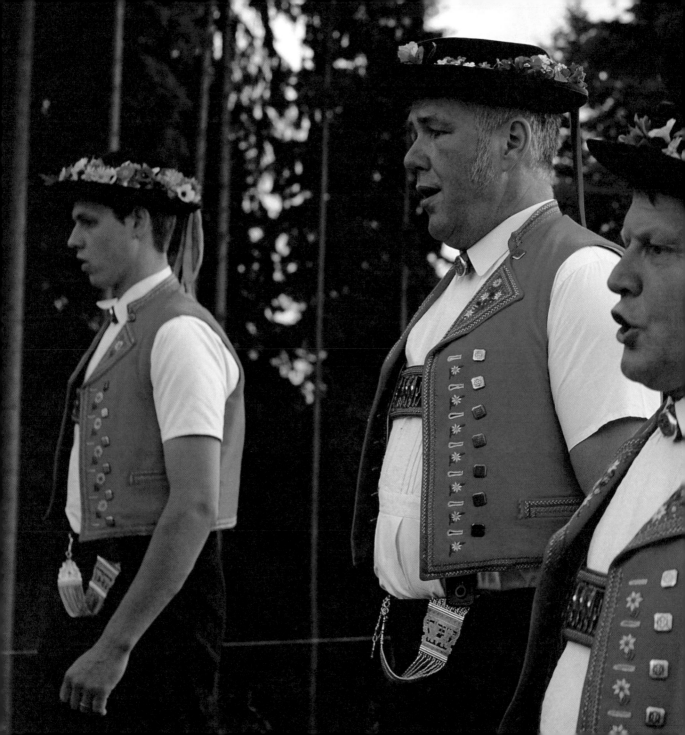

FROM TIME
TO TIME A
ZÄUERLI RE-
SOUNDS FROM
THE THROATS
OF THE
HERDSMEN.

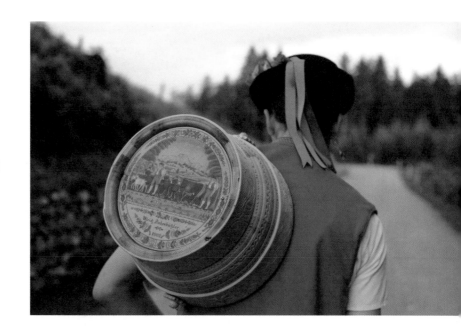

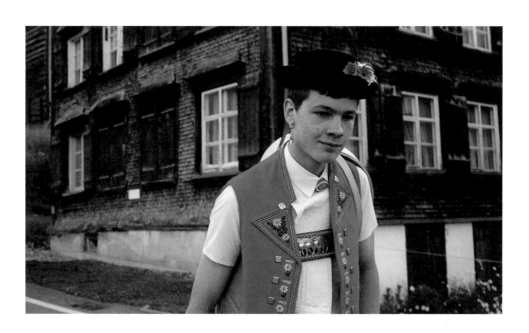

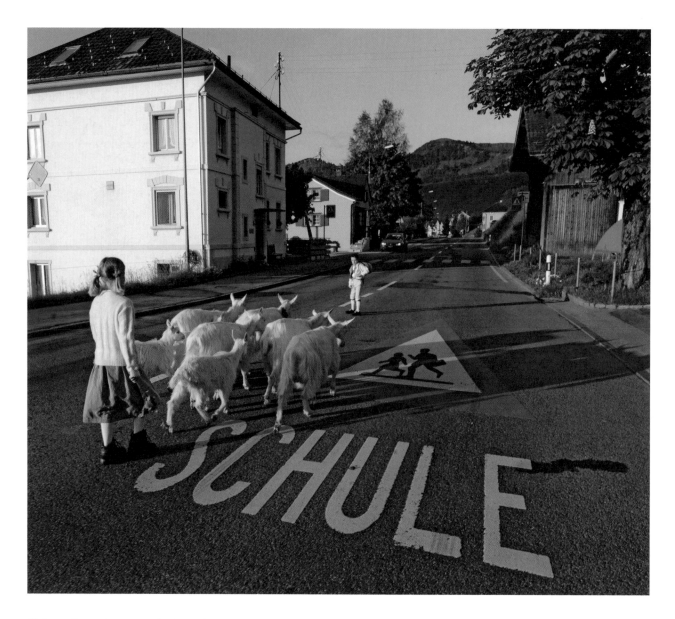

All those who can keep up on the long trek
can come along and this time the youngest is
just six years old.

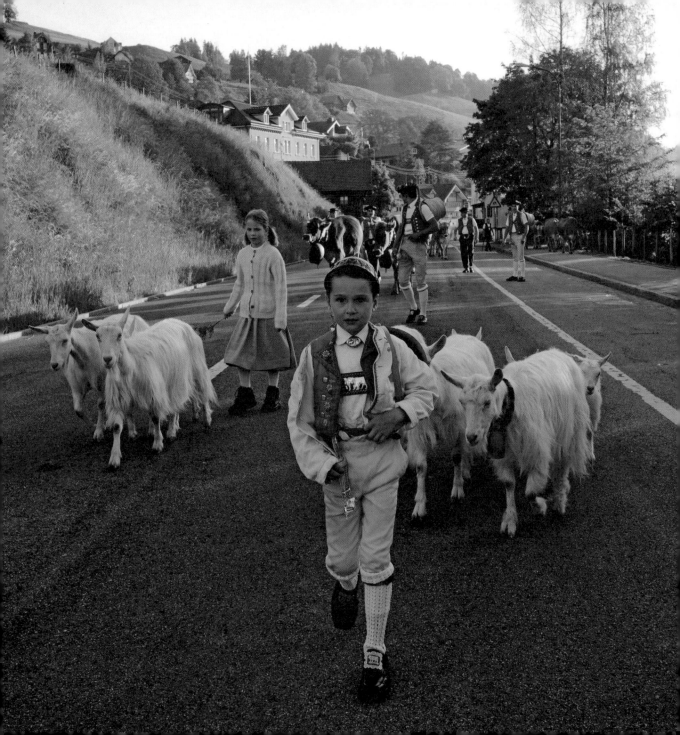

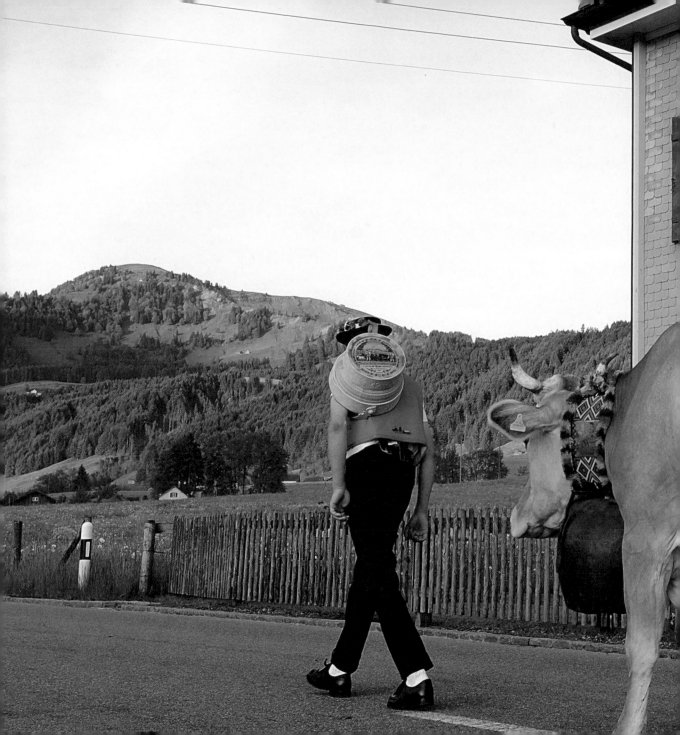

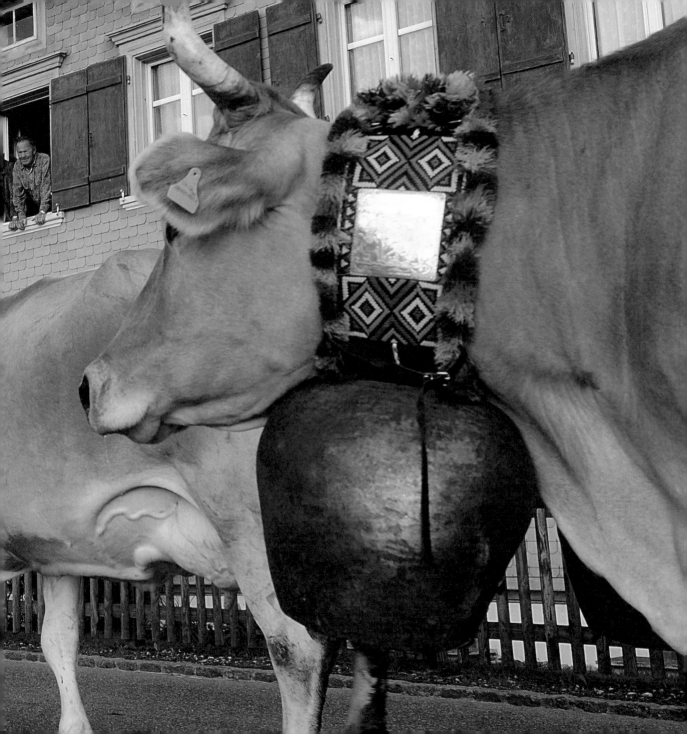

ACKNOWLEDGMENTS

Our special thanks go to everyone who helped us to realize this book project: donors, custom participants, proofreaders and all other supporters. Thank you very much!

ERNST GÖHNER
STIFTUNG

swiss arts council
pro helvetia

ULRICO HOEPLI-STIFTUNG, ZÜRICH

walter haefner stiftung

SWISSLOS
Kanton Aargau

BASEL
LANDSCHAFT
SWISSLOS

Kulturförderung Graubünden. Amt für Kultur
Promoziun da la cultura dal Grischun. Uffizi da cultura
Promozione della cultura dei Grigioni. Ufficio della cultura
SWISSLOS

Kanton Schwyz
Kulturförderung
SWISSLOS

SWISSLOS
Kultur Kanton Bern

KANTON LUZERN
Kulturförderung
SWISSLOS

Gemeinde Adelboden

Gemeinde Blatten

Gemeinde Breil/Brigels

Gemeinde Ermensee

Gemeinde Hallwil

Stadt Liestal

Gemeinde Obergoms

Peter Halter Stiftung

Gemeinde Scuol

Gemeinde Sigriswil

Gemeinde Stein AR

Gemeinde Termen

Gemeinde Untervaz

Gemeinde Urnäsch

Dominique Rosenmund
is a photographer from Lucerne. She headed the photo editorial department of the *Neue Luzerner Zeitung* newspaper and today runs her own design label matrouvaille as well as the customs shop Schlussgang, which has brought her to many Swiss craftsmen, customs and traditions.

Sibylle Gerber [SG]
is a curator at the Historical Museum of Lucerne. In her exhibitions ("Tatort", "Chilbi", "Stadtgemüse"), the cultural scientist and folklorist shows that the true wisdom of life can be found behind the stories of people like you and me. Sibylle Gerber lives in Zurich.

Karin Britsch [KB]
is editor and moderator in the newsroom of Swiss Radio and Television SRF. Raised in the Upper Valais, traditions and customs were part of her childhood and still fascinate her today. The social scientist lives in Zurich.

Stephanie Hess [SH]
is a journalist in the reporting department of *annabelle* magazine and works freelance for various media. She lives and works in Zurich.

The Deutsche Nationalbibliothek lists this publication in the Deutsche Nationalbibliografie; detailed bibliographic data are available on the Internet at http://dnb.dnb.de

ISBN 978-3-7165-1847-2

© 2020 Benteli, imprint of Braun Publishing AG, Salenstein
www.benteli.ch

1st edition 2020

Translation: Geoffrey Steinherz
Proofreading: Nele Kröger
Graphic concept and layout: Benjamin Wolbergs

All information in this volume has been compiled to the best of the editors' knowledge. The publisher assumes no responsibility for the accuracy and completeness.

For better reading, personal designations that refer to both sexes are predominantly mentioned in the masculine form. The abbreviated language form is for editorial reasons only and does not contain any evaluation.